THE ROUTE 66 PHOTO ROAD TRIP

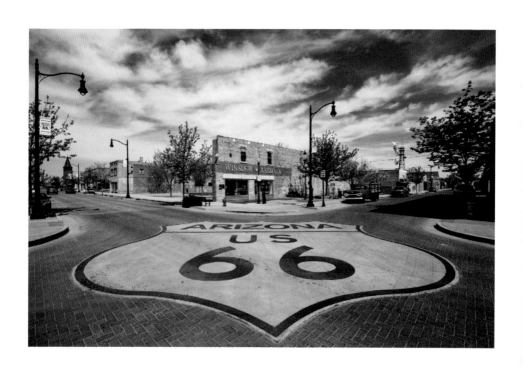

THE ROUTE 66 PHOTO ROAD TRIP

HOW TO EAT, PLAY, STAY, AND SHOOT LIKE A PRO

RICK AND SUSAN SAMMON

THE COUNTRYMAN PRESS
A division of W. W. Norton & Company
Independent Publishers Since 1923

For information about permission to reproduce selections from this book, write to
Permissions, The Countryman Press, 500 Fifth Avenue, New York, NY 10110

For information about special discounts for bulk purchases, please contact
W. W. Norton Special Sales at specialsales@wwnorton.com or 800-233-4830

Manufacturing by ToppanLeefung
Book design by Anna Reich
Production manager: Devon Zahn

The Countryman Press
www.countrymanpress.com

A division of W. W. Norton & Company, Inc.
500 Fifth Avenue, New York, NY 10110
www.wwnorton.com

978-1-68268-059-9 (pbk.)

10 9 8 7 6 5 4 3 2 1

CONTENTS

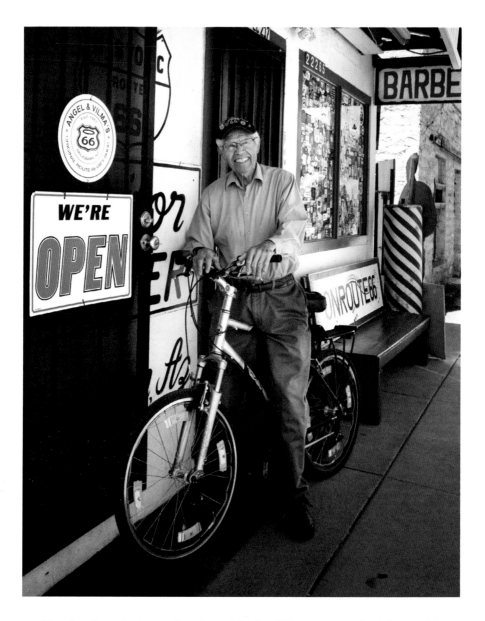

This book is dedicated to Angel Delgadillo, the angel of Route 66 and founder of the Historic Route 66 Association of Arizona.

ACKNOWLEDGMENTS

Our first acknowledgment is to you, the reader. Thank you for purchasing our book. We wrote it with you in mind, and took the pictures to inspire you to make an awesome road trip.

We'd like to thank Bob Sammon, Rick's brother, for taking a look at our manuscript before it went to the publisher. Bob is an excellent proofreader/editor, and a good friend.

A big thank you goes to our friend Glenn Taylor, whose wonderful Route 66 photographs inspired us to make this road trip—twice.

John and Jo Van't Land also get our thanks—for their hospitality in Gallup, New Mexico . . . and for letting me stand on the roof of their SUV for my train photograph.

We'd also like to thank Hertz, who rented us an awesome Dodge Charger. Those "hot wheels" made our first Route 66 trip truly memorable—and a ton of fun!

As a Canon Explorer of Light, Rick would like to thank Canon USA's Dan Neri, Len Musmeci, Rob Altman, Rudy Winston, Chuck Westfall, and all his friends at Canon CPS for supporting his photographic endeavors since 2003.

And, of course, we'd like to thank all the folks at The Countryman Press for their help with this book.

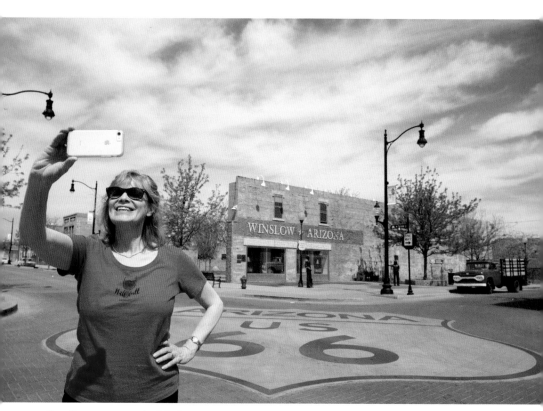

Standing on a corner in Winslow, AZ

PREFACE: WHY DO A ROUTE 66 ROAD TRIP?

Photographers will take long trips by land, sea, or air just to capture good images. Of all the road trips in all the world, why travel the Historic Route 66?

Here's why:

1. Driving in your car on Route 66 is like riding in a time machine. With some imagination, you can transport yourself to the 1950s and 1960s, when cars and buildings, had unique personalities.

2. Photo opportunities are everywhere if you seek them out. The vintage cars, neon-lighted buildings, and happy people make wonderful subjects.

3. Historic Route 66 is very accessible from I-40. Just follow the brown Historic Route 66 signs. Pull off the interstate and drive into town and you'll feel as though you are miles away from the hustle and bustle of modern everyday life.

4. You will meet some wonderful people in the restaurants, at the hotels and motels, and in the shops. Everyone we met was exceptionally friendly and happy to pose for photographs.

5. Drive time can be thinking time. Driving from city to city gives you time to reflect on what you have seen and photographed.

6. Once you arrive on-site, you don't have to get a plane to go from location to location until your trip is over. Being self-contained and in total control of your schedule is a wonderful and freeing feeling.

7. Your road trip will not break the bank if you plan wisely. It's a vacation just about everyone can manage.

Seligman, AZ

8. You will be challenged (which is a good thing for a photographer) to make pictures that don't look like the same old Route 66 images you have seen countless times.

9. You will have a ton of fun on the road trip of a lifetime. We can say that with some authority because we have been to about 100 countries, and we think that traveling on Route 66 is still one of the best photo trips a photographer can make.

Using This Book

We wrote this book with two main goals in mind. First, you can use it as a planner to make the most of your road trip. Second, it can be your on-site companion to help you have the most fun and make the best photographs during your time on our favorite part of Route 66.

In planning your trip, we suggest that you read the chapters in order. They were written in the order in which we visited each location and in the order you will most likely be visiting each location on your one-way

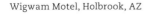
Wigwam Motel, Holbrook, AZ

Rick at work on Route 66

road trip. That way, you will be able to plan your trip from start to finish, getting a good idea of the locations that lie ahead. And when it comes to discussing photographic processes, such as HDR (High Dynamic Range photography), we will start with a detailed explanation, and then briefly mention the technique as we motor along, so to speak.

If you are new to making road trips, our **Road Trip Tips** section (page 14) will get you prepared for spending time in the car, in hotels, in cities, and in the great outdoors.

We also recommend that you read our photo tips in the **Jump-Start Your Route 66 Photography** chapter (page 26) before you take a trip. We will discuss techniques, such as HDR and smartphone processing that are briefly mentioned in each chapter.

Can't wait to see all exciting stops you will make? Check out our **Driver's Log** on page 214. It includes all the places we visited, including their addresses.

We hope you enjoy the ride!

Rick & Susan Sammon

FOREWORD: ROAD TRIP TIPS

Can't wait to get on the road? We understand. However, before you put your car into drive, we suggest you check out these road trip tips, which will make your trip more enjoyable, productive, and safe.

Planning: This is an essential part of any road trip. Sure, it's good to be flexible, but planning your route and calculating the drive times between your destinations, hotels, and dining spots will help ensure a smooth ride.

We booked all our hotels well in advance of our departure, and stuck pretty much to our planned schedule.

Hackberry General Store, Hackberry, AZ

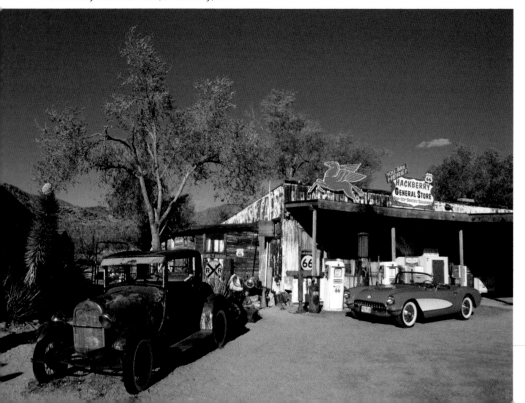

Car: We booked a full-size car for three reasons: comfort, road safety, and because we could store all of our bags (including camera and computer cases) in the trunk. Keeping cargo out of sight helps keep it safe, as bags visible through backseat windows can be a targets for thieves.

GPS: Of course, smartphones offer great GPS features . . . if you have service. We strongly recommend using a separate GPS unit for your road trip. Before we left home, we plugged most of our destination addresses into the unit. Once on-site, we added more.

The GPS will also help you determine drive times between destinations.

Drivers: We shared the driving during our 9-day road trip. This made the ride more fun, especially for Rick, who likes to take a nap every day!

Having two drivers also helps with navigation and betters your chances of spotting potential photo opportunities.

Travel Apps on Cell Phones: If you have a cell phone with good service, you can use apps to help find locations and services along the way. You can also enjoy some great tunes while on the road from one location to the next.

Here are the apps and services we use to both plan our trips and support our needs while on the road.

1. Google Maps—Find locations quickly by address. Plug in your next stop and get the estimated drive time.

2. Trip Advisor—Find a list of hotels in the area. Good for planning ahead, or for those unexpected overnights.

3. Yelp—You have to eat. Find restaurants with good food and ambience. Read reviews to identify places with vintage Route 66 charm.

4. Travel Altimeter—Keep track of your altitude. You might be surprised at how high the road takes you. Drink more water to avoid the unpleasant side effects of high altitude.

Colorful mural in Seligman, AZ

5. Weather.com—Good for getting a preview of temperatures in upcoming locations. Also a fast way to get sunrise and sunset times so you can capture images in good light.

6. Spotify—Streaming music is a great way to enjoy your favorite tunes while traveling. You can also browse some great playlists under "travel." Favorites include: Heartland Drive, Family Road Trip, and Drive Through the Mountains.

Water: You can't drink too much water, especially when you are going through the desert and high desert. We always had several bottles of water in our car so we never went thirsty.

Exercise: Sitting for hours on end makes muscles stiff. Every once in a while, take a break, make a pit stop, get out from behind the wheel, and do some stretching.

Eating: It's tempting to indulge when you encounter lots (and lots) of great New Mexican food and fast food on the road, but try to eat as healthy as possible. Eating healthy will give you more energy.

Driving: On I-40, the road that you will take between your stops on Route 66, cars passed us going 80–90 miles per hour in a 75 mile-per-hour zone. Be alert. Be careful. Check your rearview mirror often.

Gas: On our first trip on Route 66 we almost ran out of gas. That was not a good feeling! Get gas whenever you can. Or follow my dad's advice: never leave for a destination with a half a tank of gas.

Note that cars tend to burn more gas at 75 miles per hour than they do at 50 miles per hour, so you may see your gas level dropping faster than expected.

Altitude: Many of your destinations are well above sea level. Along our trip, we hit up spots well above 5,000 feet.

Higher altitudes can give some folks headaches, which can be eased by drinking a lot of water and not too much alcohol. Ibuprofen can help, too. Altitude can also disrupt sleep, so be sure to give yourself plenty of time for rest.

Also, plan on dealing with jet lag if you are coming from a different time zone. A well-rested driver is a good driver.

Clothing: Clothing is an important part of your road trip planning. Some of our days at the Grand Canyon started out near freezing and ended up in the 80s. Dressing in layers helps keep you comfortable.

You will also want to have sneakers for street walking and hiking boots for exploring the Grand Canyon, Tent Rocks, and Red Rock State Park.

And don't forget a hat, as well as sunscreen. It's easy to get a sunburn when you are outside for most of the day, especially at high altitude.

AAA: If you drive your own car and do not belong to AAA (Automobile Association of America), we strongly recommend you become a member. You never know what can happen on the road, and in the (hopefully unlikely) event of an emergency, AAA will provide roadside assistance. AAA works when driving a rental car, too. It can also get you a discount on hotel rooms.

Follow our tips and you will be better prepared for what we feel is one of the best road trips around.

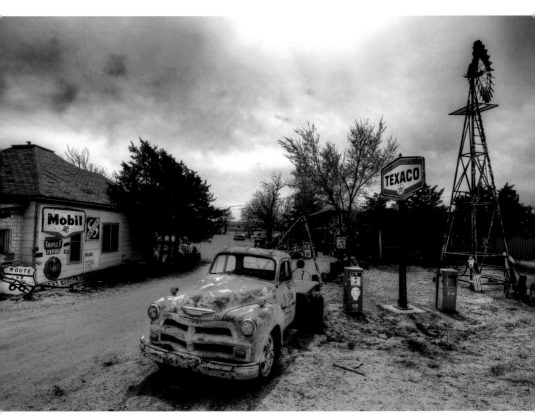

Tucumcari, NM

INTRODUCTION

ROUTE 66 IS NOT A ROUTE TO GET YOU TO A DESTINATION . . .

IT IS THE DESTINATION.

Travelers of all ages love road trips. Being on an open highway with no TSA lines to be herded through imparts a great sense of freedom and presents many opportunities for discovering new places, meeting new people, and experiencing regional ways of doing things.

When we travel, we become immersed in the experience—so long as we are not rushing off to our final destination. It is a joy to watch the changing landscapes and cityscapes outside the car window and smell the country air when we make a stop. It is a wonderful sensory experience.

No group enjoys a road trip more than photographers, because a road trip also presents a colorful palette of visual inspiration. Towns, main streets, historic sites, natural wonders, and local characters are all available to catch the photographer's eye. We are excited to stop and record images of what we see and feel. From wide-angle vistas to grainy details, the possibilities call us to action.

We have found that a successful photo road trip requires two things: an open mind and the time to wander. Planning is important, too, but it is best not to overdo it. We always leave room for unexpected side trips and pop-up photo experiences. Sometimes we adjust everything—from hotel reservations to tour bookings—when a great photo opportunity presents itself. The key to doing this is to stay flexible!

When we take a photo road trip, we try to capture images that tell a complete story. We don't want just a series of pretty pictures.

To tell the story of any road trip, make stops along the way. Get out, take a look around, have a meal, stay overnight in unique hotel or motel, talk to the local people, and sample local foods and specialties. A variety of photographic subjects work together to tell a compelling story.

Driving along portions of Historic Route 66 is a dream for road trippers. It has all the ingredients for inspiration, from dramatic

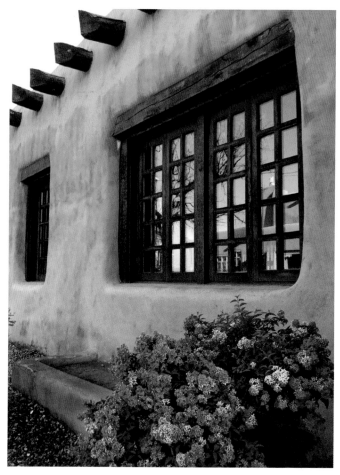
Santa Fe, NM

landscapes and dusty towns to vintage cars and retro diners. It's a wonderland, but not every location presents an obvious photographic subject. Sometimes you may get out of the car and wonder why you stopped. A small town can have a deserted feeling. But take some time to absorb the surroundings. Walk around and take in the vibe. Sometime it takes a change in light or a stir of activity to point you in the right direction.

Our favorite section of Route 66 (also the most popular one) rolls

through the high desert of New Mexico and Arizona. It starts in Tucumcari, New Mexico, and concludes with a stop at a ghost town in Nelson, Nevada.

Our photo "prime cut" of Route 66 includes the cities of Albuquerque and Santa Fe, along with the small towns of Tucumcari, Santa Rosa, Gallup, Holbrook, Winslow, Williams, Seligman, Hackberry, Kingman, Chloride, and Nelson.

We think the best time of year to take the drive on our prime cut of Route 66 is in spring, sometime between March and May. Temperatures are moderate in the day and cool at night. Remember that you will be traveling at high altitudes—from 3,000 feet in Chloride, Arizona, to 7,000 feet in Santa Fe, New Mexico. Keep a jacket, hat, and gloves handy. This is also a very sunny part of the country, so sunglasses and wide-brimmed hats make sense, too. We hear the fall months of October and November are also a lovely time to make a Route 66 road trip. Pick which season works best for you and your schedule.

We enjoy traveling Route 66 from east to west. This route pays tribute to the highway's original spirit, following the history of westward expansion. Note that the first segment of our recommended itinerary, from Albuquerque to Tucumcari, travels east. After that leg, the rest of the trip moves westward. In all, we traveled 1,650 miles. We welcome you to follow our route, but of course you can customize your own adventure.

Historic Route 66

Much has been written about the history of Route 66. There are books, magazine articles, and many online references. Here's the basic story: During the 1950s, many Americans bought cars and headed for the road. Driving gave families a new freedom to travel for vacation or to pick up and move to another part of the country. The US highway system was developed to support this expanding mobile society.

Route 66 was part of the growing highway system that throughout much of its course runs parallel to existing railroad tracks. The original road started in Chicago, Illinois, and ended in Los Angeles, California. As

Route 66 became a popular route, many towns built motels, restaurants, and roadside attractions along its path to support travelers.

Popular culture increased Route 66's visibility and transformed it into a symbol of freedom for a new generation of Americans. The road took on a legendary status through references in books like *The Grapes of Wrath* and in songs like "Get Your Kicks." There was also a television show that Rick used to watch, *Route 66*. More recently, the Pixar movie *Cars* added to the legend and lore.

Things changed in the late 1970s when I-40, which parallels Route 66, opened. As a result, people switched to the faster and safer interstate, bypassing the towns along the fabled Mother Road. Without customers, local businesses struggled. Some disappeared and a few survived. Today there is no official Route 66. What is left is a series of segments of road that can be easily accessed and are well-marked from I-40.

Modern-Day Route 66

Today, traveling on Route 66 is a different kind of journey than it was in the 1940s, 50s and 60s. It is not a route to get you to a destination. It is the destination.

What you'll find are sections of the original road that can be easily visited, explored, and photographed. You can also grab some local food and sometimes a Big Mac or Egg McMuffin along the way.

Many of the small towns still support travelers from I-40. There are plenty of new chain motels and chain restaurants off the interstate highway. But if you follow the brown "Historic Route 66" signs, you'll find the remains of the tourist towns, with neon lights, retro hotels, and vintage cars from years past. The fun part is seeing—and of course photographing—what remains.

As we mentioned earlier, we did not travel the full length of Route 66. We traveled a selected route, mostly in New Mexico and Arizona, or what we call our "prime cut." You can expand or contract the trip to fit your needs. Even if you cannot stop in every location on our itinerary (listed in order in the **Driver's Log**, page 214), we hope you

will be inspired to stop at some of our favorite spots mentioned in this book.

Trip Planning

In the old days we used to plan a road trip with a paper map and guide-books. We would also contact people we knew who had taken a similar trip to get a first-hand account. Today, we used the Internet to get infor-mation and inspiration. But we still contact friends to get their personal recommendations. In fact, our first trip on Route 66 was set in motion when a photographer friend, Glenn Taylor, shared his images with us. We loved the feeling his photographs conveyed and wanted to experi-ence the road for ourselves. Glenn was very generous and provided us with his travel log. It was a great starting point. Since then, we have been sharing our Route 66 itinerary with other photographers in an informal way.

We consider this book to be our way of passing along our recom-mendations to friends we have not yet met!

Safe Travels!

PART I

JUMP-START
YOUR ROUTE 66
PHOTOGRAPHY

RICK'S QUICK PHOTO TIPS FOR ROUTE 66—
FOR DIGITAL SLRS & MIRRORLESS CAMERAS

We hope you never have to jump start your car on your Route 66 road trip. Jump-starting, however, can be good thing—especially when it comes to getting a jump on photo ideas and techniques. That's what I will talk about in this section, using some of the photographs you will see throughout this book.

I will start with HDR, because I mention it more than a few times in this book and because it is necessary to get a good exposure in a very high contrast situation, such as when you are photographing from inside a car to outside, or when you are photographing from inside a building to outside.

Then I will move on to composition which, as famed photographer Edward Weston said, is "the strongest way of seeing."

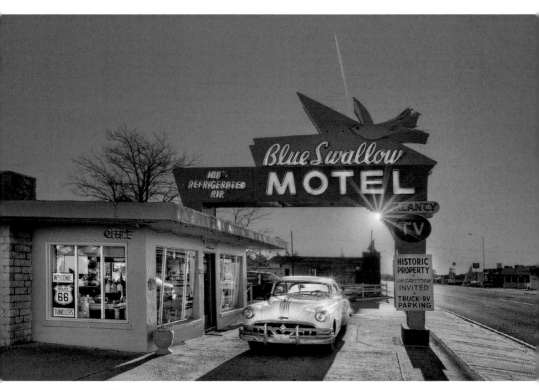

Tucumcari, NM

The Magic of HDR

HDR stands for High Dynamic Range imaging. HDR is a process in which you take a series of photographs at different exposure settings/values over and under the recommended/average exposure setting—and then use a HDR program, offered by Photomatix, Nik, or Lightroom, to merge those files into a single image that shows detail in both the shadows and highlights.

In very high contrast situations, HDR images show a greater dynamic range than can be captured in a single file or processed from a single file. They can also show a greater dynamic range than even the human eye can see.

The opening image in this section of the Blue Swallow Motel in Tucumcari, New Mexico is one of my favorite HDR images.

Before I take you through the HDR process, here is some basic HDR must-know shooting information:

- The aperture must remain the same for all the exposures; you bracket your exposures with the shutter speed.

- Use the lowest possible ISO for the cleanest possible images.

- Using a tripod is a good idea, especially when the light level is low. I used a tripod for my Blue Swallow Motel image.

However, if you are shooting with a wide-angle lens and use rapid frame advance, you may be able to handhold HDR images if you hold your camera very steady. The wide-angle lens and rapid frame advance combination works because wide-angle lenses and shooting at a fast frame rate show less camera movement between frames, making it easier for HDR programs to align images.

- You need to capture the entire brightness range of the scene. That means taking enough photographs under the recommended exposure setting until you have no "blinkies" (your camera's highlight

alert), and you need to take enough overexposed photographs until you can see into the shadows.

- The greater the contrast range, the more photographs you'll need to take. For example, when you shoot toward the sun or a light source, you will need more exposures than you do when you are shooting with the sun at your side.

- Most pros bracket in 1-stop increments, but 2-stop increments can work if the contrast range is relatively narrow.

- In-camera HDR works well if the contrast range is not greater than four f-stops.

Here are the photographs that I took to create my HDR image. Six images were needed to capture the dynamic range of the scene. My camera was on a tripod and I bracketed my exposures manually.

I use Photomatix, my preferred HDR program, to create what I call my HDR negative. I call that file an HDR negative because I always move that file into Lightroom or Photoshop for more image processing so there is no need for me to go though all the other Photomatix adjustments.

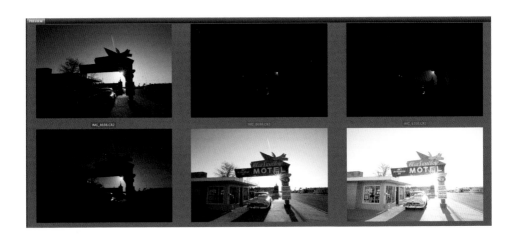

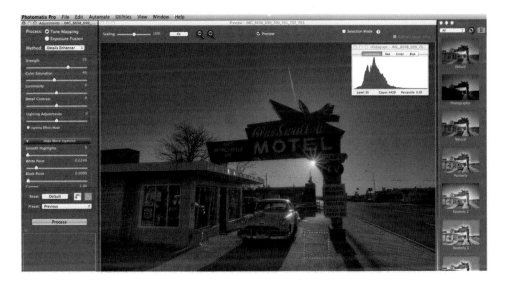

To create my HDR negative I use only three adjustments in Photomatix: White Point (highlights), Black Point (shadows), and Lighting Adjustments (halos).

I start my HDR processing with those three sliders moved all the way to the left. I move the White Point slider to the right until the highlights start to get washed out, and then I move it back to the left to preserve the highlights. You can use the histogram to check your adjustments and levels, making sure you do not have a spike on the right. That spike would indicate overexposed highlights.Next, I move the Black Point slider to the right until the shadows start to get blocked up and then I move it back to the left until I am pleased with the shadow detail. Again, you can use the histogram to make sure you do not have a spike on the left. That spike would indicate blocked up shadows.

Finally, I move the Lighting Adjustments slider to the right until the haloes are gone. Haloes are the dead give away to a poorly processed HDR image.

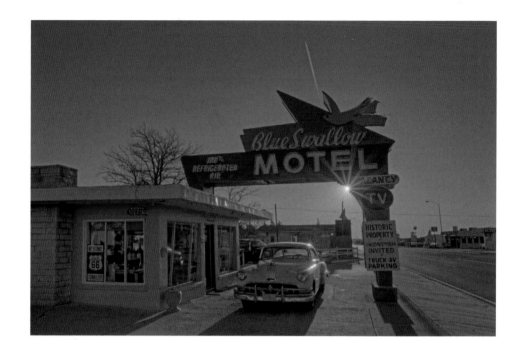

Here is the HDR negative for my Blue Swallow Motel image. You can see into the lobby of the motel, and the sky is not overexposed. The image, however, looks flat. That happens when the shadows are opened up and the highlights are toned down. But we're not done.

You'll also notice a dust spot in the sky and a perspective problem: it looks as though the building is leaning inward—a parallax problem caused by shooting close to the building with a wide angle lens. I removed the spot using the Content Aware feature in Photoshop. While still in Photoshop, I fixed the perspective by first Selecting All and then by going to Edit > Transform > Perspective and then pulling the top left anchor point outward (you can get the same effect by using the top right anchor point).

To transform the flat image into a much more dynamic image, I used Adobe Camera Raw. The same basic controls are available in Lightroom.

The image looks flat at Camera Raw's default settings.

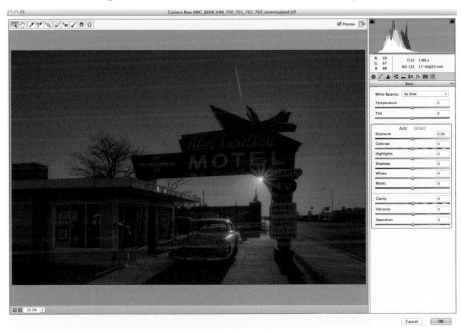

But look what happens when I made the following adjustments.

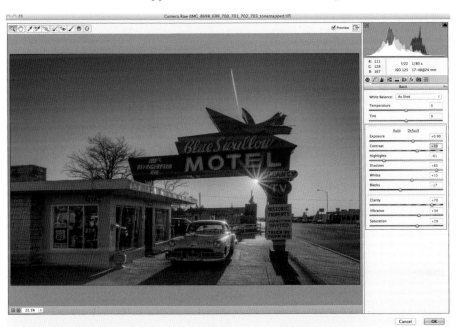

Increased:

Exposure—makes an image brighter

Contrast—creates a stronger difference between the shadows and highlights

Shadows—opens up shadow areas

Whites—brightens the highlights

Clarity—makes the image look sharper by increased the detail

Vibrance—increases the saturation of non-saturated colors

Saturation—increases the saturation of all the colors in a photograph

Decreased:

Highlights—bring back (and rescues in some cases) detail in bright areas

Blacks—makes blacks look bolder and adds contrast to a file

As a further enhancement, I added a Bi-Color filter in Nik Color Efex Pro. That filter enhances and/or changes the color of the sky and foreground in a file.

Finally, I brought the image back into Photoshop and used the Dodge tool to lighten the letters in the Blue Swallow Motel sign.

A bit of work, but as you can see, hard work (if you call playing with HDR, Photoshop, and plug-ins work) pays off.

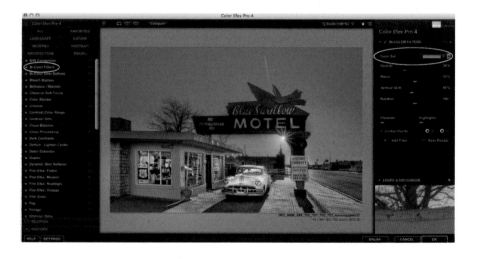

Composition Is King

Good composition is a big part of making a good photograph, and the sights and subjects along Route 66 offer a wonderful opportunity to get good at composition.

Here are my quick tips for good composition. Check these out and you will get a jump start on making good photographs.

Frame It: A photograph is really a window into a scene. Framing a scene through a window can make for a very interesting and dynamic photograph.

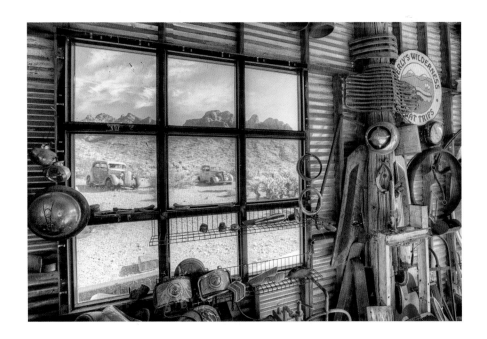

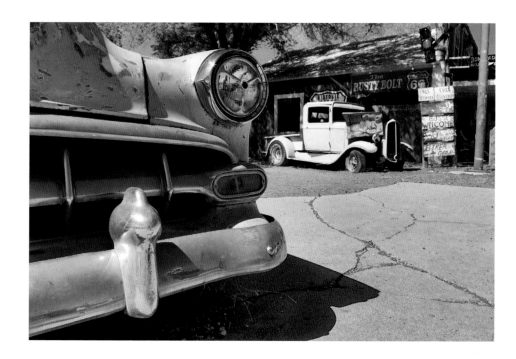

Move Up and Down: Taking all your pictures at eye-level can get boring. Move your camera up and down for more interesting and compelling compositions.

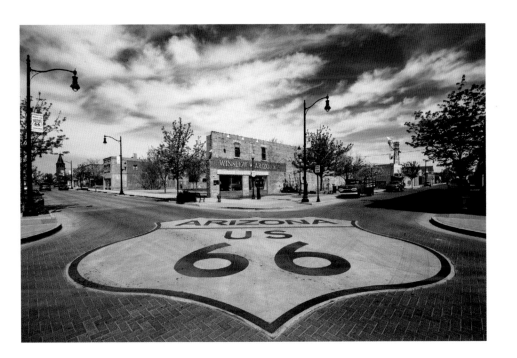

Foreground Elements Are Essential: Foreground elements add a sense of depth to an image. When you don't have a foreground element, use the ground as your foreground element.

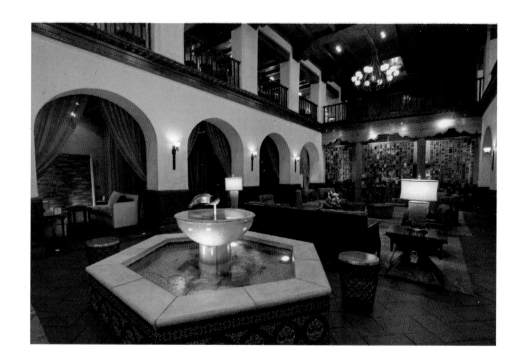

Love Layers: Composing in layers also adds a sense of depth to an image. This photograph has three layers: fountain, seating area, and rear wall.

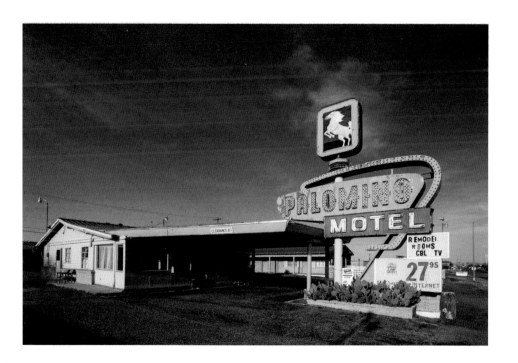

Negative Space Is Nice: There is a lot of negative space (the sky) in this pho-
tograph. It adds a nice open feeling to the photograph.

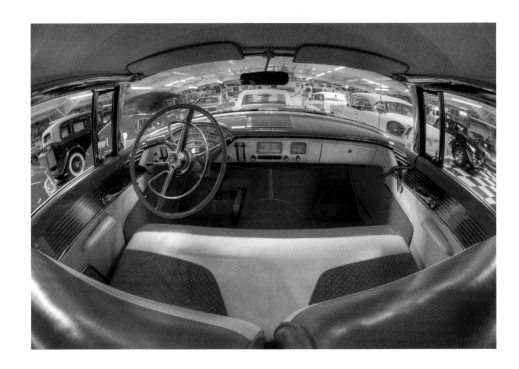

The Name of the Game Is to Fill the Frame: Quite the opposite of using negative space; every inch of this photograph is filled with an interesting element.

The Rule of Thirds Rocks: Imagine a tic-tac-toe grid over a photograph and place the main subject (the man's head in this case) where the lines intersect.

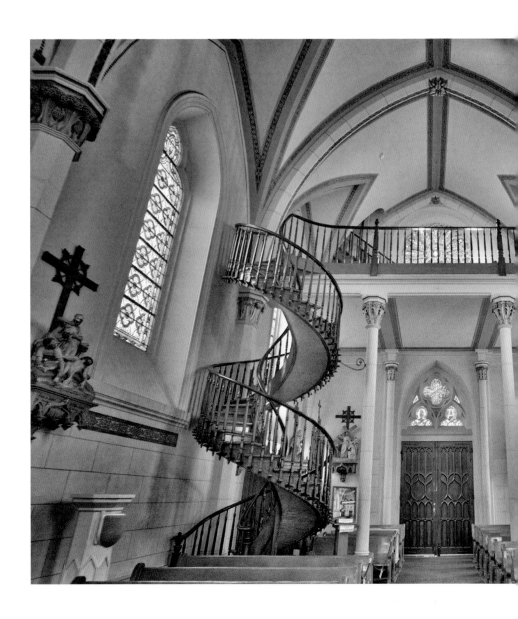

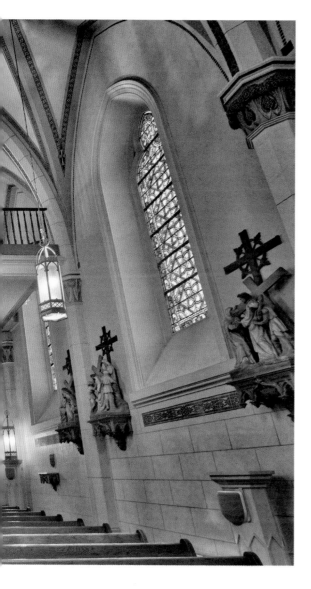

Embrace Distortion: Tilting wide-angle lenses creates distortion, which can easily be fixed in Photoshop and Lightroom. That being said, sometimes it's good to embrace distortion, as it can help to create a cool-looking image.

Love Leading Lines: Lines, the train tracks in this case, lead the viewer into a scene and to the main subject.

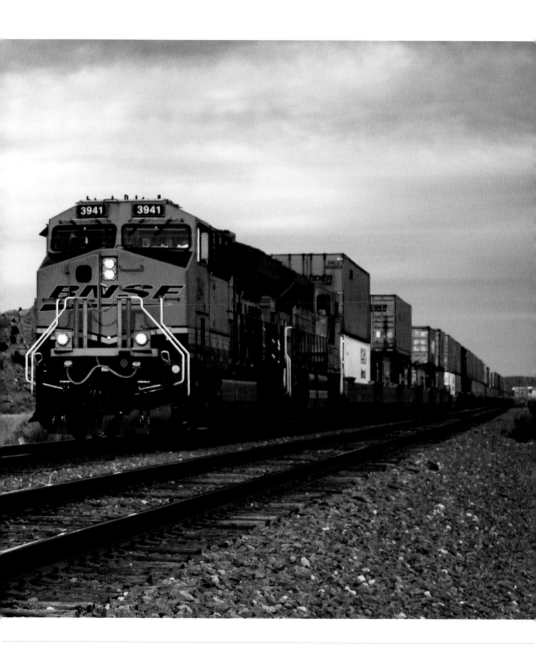

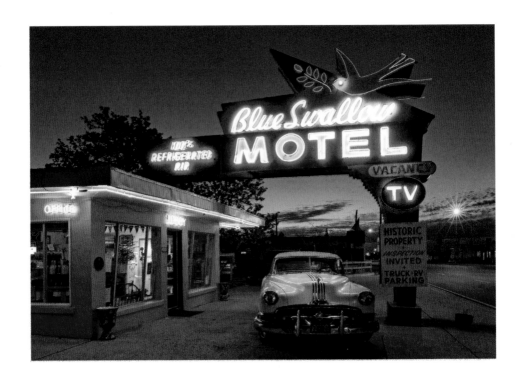

Get Up Close: When you think you are close, get closer. The closer you are to the subject, the more intimate the photograph becomes.

Seek Separation: We see the world in 3-D, while our cameras see in 2-D. To isolate objects in a scene, seek to separate them. This composition technique will add more depth to an image.

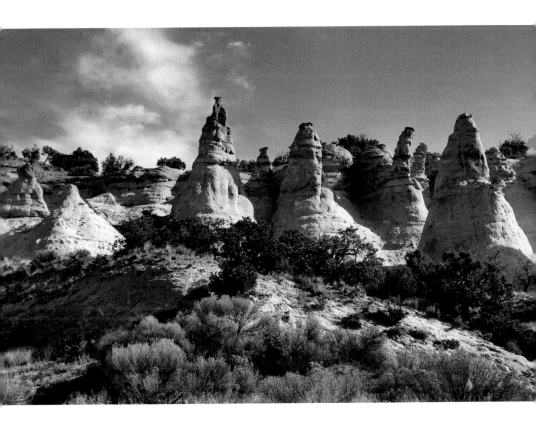

Be Aware of the Background: Before you take a photograph, look at every detail in the background. Composing this photograph with the American flag in the background added a nice touch.

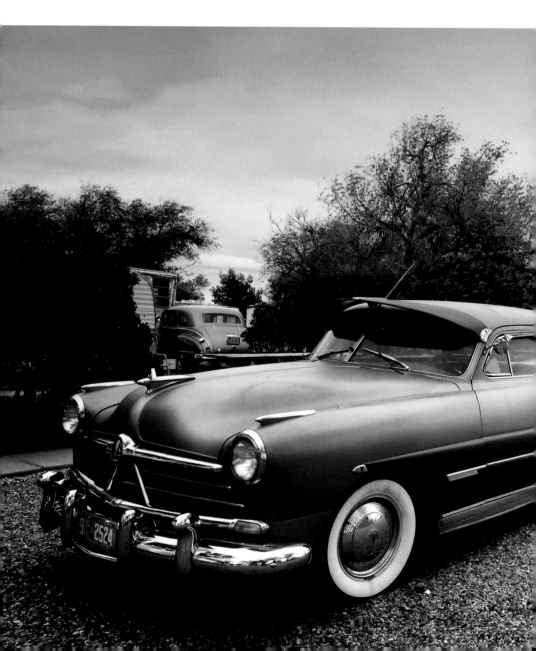

Play with Patterns: Patterns, as well as abstract elements, help to make unusual and eye-catching photographs. You might not know this is a close-up of a piece of petrified wood if I hadn't just told you.

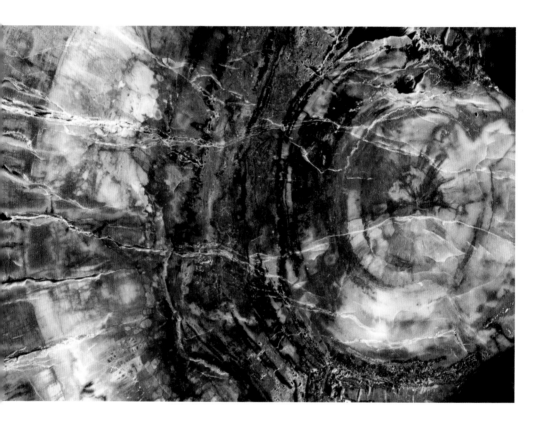

Make Pictures, Don't Just Take Pictures: I made this picture by positioning the gate in the foreground so that it added a sense of "being there" to the photograph.

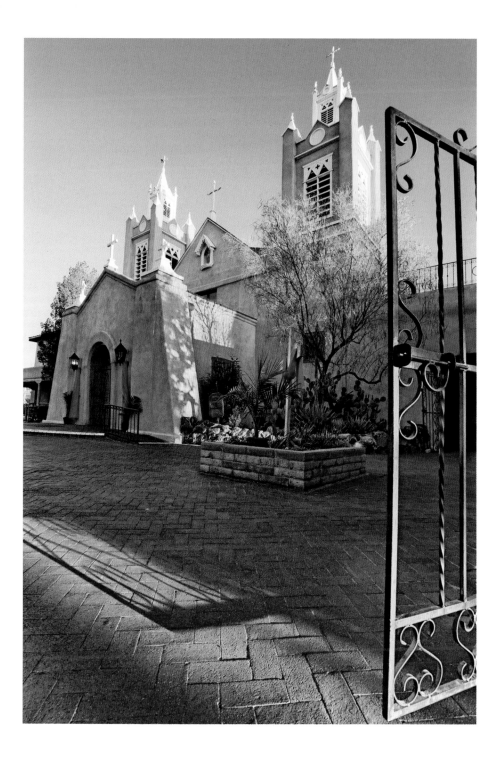

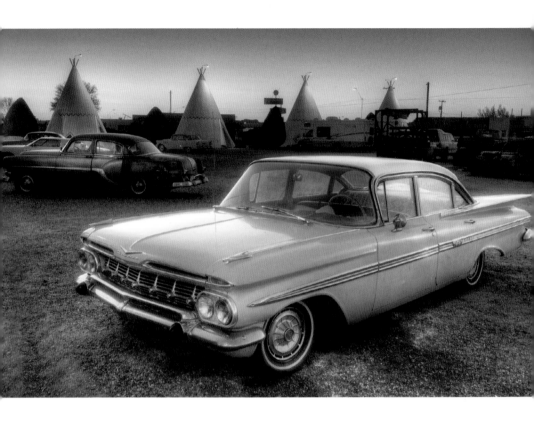

All Together Now: Use several composition techniques in concert to make a compelling and artful photograph. The techniques used here include:

- Foreground element that adds a sense of depth to the image

- Separation—notice how most of the elements in the scene are separated

- Horizon line placement—it's placed near the upper part of the frame, which is much more interesting than when the horizon line is in placed in the center of the frame

- Photographed from above eye level for an interesting view

- The main subject was placed off-center

- Being aware of the background

- Close to the subject

- Different layers also add a sense of depth to the image

- Filled the frame

Finally, use what I call "croposition," that is, combine thoughtful composition with careful cropping in Photoshop or Lightroom for an interesting photograph.

SUSAN'S ROAD TRIP PHOTO TIPS—
FOR SMARTPHONE CAMERAS

Nowadays, we're all photographers. Virtually everyone has a cell phone with a camera. If you always carry your phone, you always have a camera. Learn how to use it—with some skill—and you can join the growing ranks of smartphone photographers who enjoy posting their memories on social media, creating photo books, and making prints for display in their homes.

Not all smartphone photographers, however, make good photographs. Even though the newer cell phone models have more advanced cameras, higher quality lenses, and more powerful photo processing apps, they still need a savvy shooter to produce a good image.

To make the most of your smartphone image-making potential, here are my tips and techniques for taking and processing eye-catching smartphone photographs. I use an iPhone, but these tips and techniques apply to other smartphone brands as well.

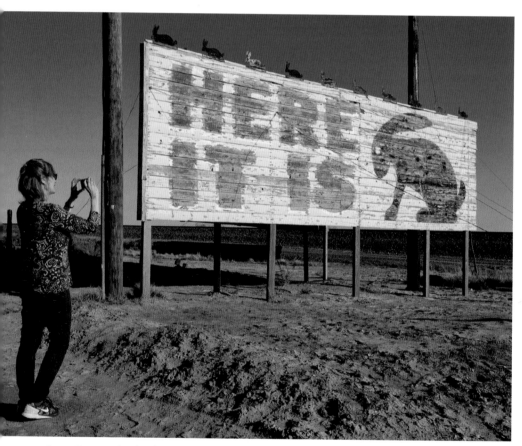

Susan Sammon having fun at the famous "Here It Is" sign.

Think Before You Shoot

It's an everyday occurrence: When you see a scene that you think will make a good photo, you whip out your phone and snap a picture. But later, when you look back at the image, you might say to yourself, "What was I thinking?"

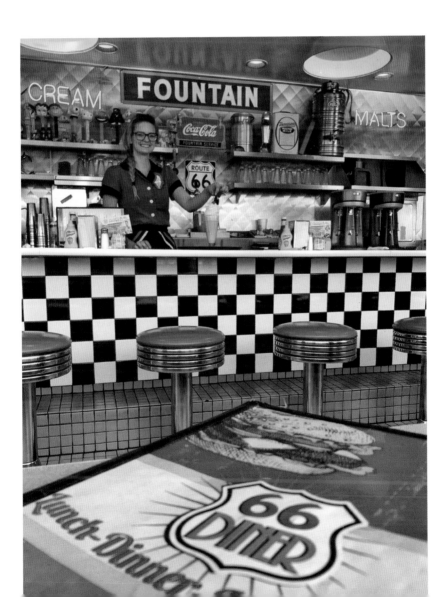

Many times the problem is a lack of a main subject or focal point. Before you take a photo, ask yourself, "What is the main subject?" It could be a person, animal, building, tree, flower, or plate of food. Even a color, pattern, texture, or close-up detail can be a subject. Keep in mind that if you have trouble identifying the main focus or subject, the shot might come up short.

You can often transform a scene without a focal point into a more pleasing image by using careful composition. Find a tree, fence, or curvy stone wall to include in your landscape. Wait for a crashing wave or a flock of birds in a seascape. Cityscapes will come alive by including moving traffic. When you are taking people pictures, make sure your subject is prominent in the frame. Move in closer to your subject and your photo will have more impact. Avoid a busy background when photographing people, as it can distract from your main subject.

Compelling subjects are important. Look for them and your photos will improve.

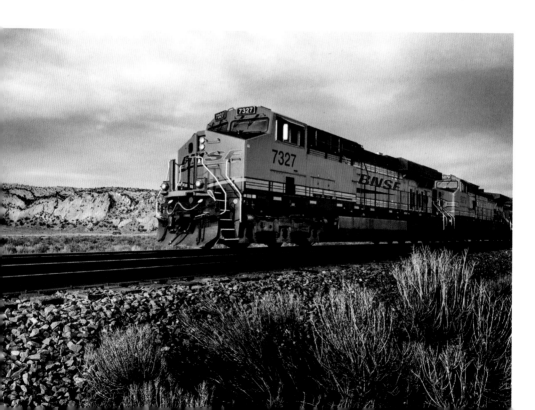

The Basic Rules of Photography Apply

There are no high-tech shortcuts to being a good smartphone shooter. You need to understand the basics of focus, exposure, and composition to create consistently good photos.

Here are my thoughts on how the photography basics apply to smartphone photography.

Focus: Good photos are in focus. Smartphone cameras use auto focus technology and provide an in-focus image most of the time. But sometimes, your images will look soft. To get in-focus photos, consider three things:

1. Hold steady when you press the shutter button. Using both hands to hold the phone will make you more stable when you shoot.

2. Use the touchscreen to select the exact point of focus. On an iPhone, a focus box will appear where you touch the screen. After you select the focus point, press the shutter button. For tricky focus situations, you may want to use the focus lock feature (keep your finger on the screen until the focus box locks) to select the focus point and then recompose.

3. Do not expect clean (without digital noise) and sharp photos in low-light situations, especially in photos taken indoors and at night. Go ahead and capture a fun memory, but be prepared for a noisy image.

Exposure: Pleasing images are properly exposed so that the main subject pops. Again, your smartphone will select the exposure automatically. Most of the time, this works just fine.

When you want to control your exposure, activate the touchscreen exposure feature by placing your finger on the screen until the sun icon appears (on the side of the focus box). Now, there are two ways to control the exposure. For fast results, tap the main subject to select the point of exposure. If the subject looks dark, touch something darker to brighten the overall shot. If the subject is too light, touch a lighter area to darken. Experiment until you get your best exposure, and then press the shutter button.

The second way to adjust the exposure is to activate the exposure control slider. Tap your finger on the screen until you see the sun icon. Slide your finger up (anywhere on the screen) for more light and slide down to darken. This takes a little practice. You will see the sun icon

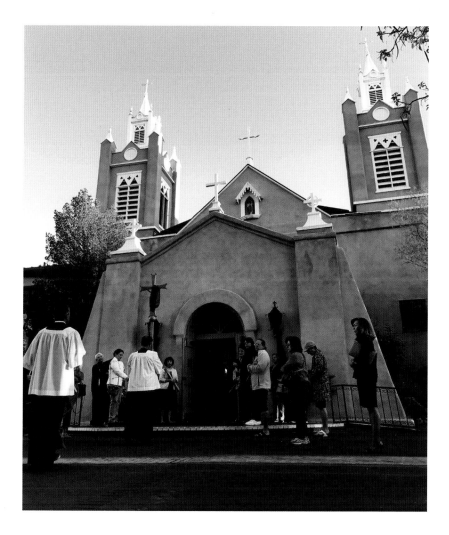

moving up and down when it is properly engaged. This is the way I control exposure on almost every shot.

Other ways to improve exposure in your photography include some old-school ideas. Keep the sun at your back in landscape photos. Ensure the face of your subject is well-lit in portrait work by either moving your subject into better lighting or activating the in-phone flash.

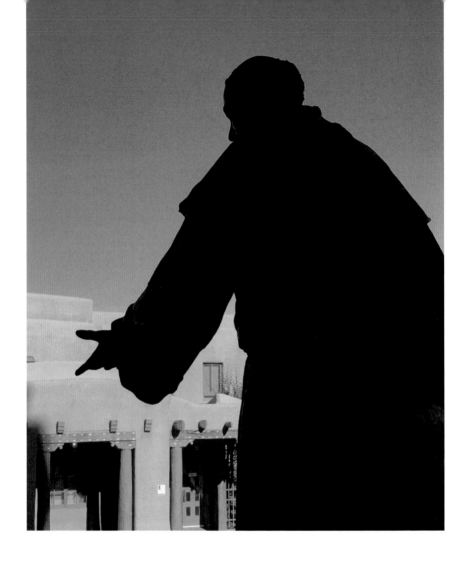

For a creative look, try taking a silhouette of a subject. This can look great, especially with a colorful sunrise or sunset. Position yourself facing your subject with the sun behind them. When you take the shot, your smartphone camera will automatically produce a wonderful silhouette. If needed, use the exposure control slider to increase the contrast of the silhouette to make it more dramatic.

Composition: Interesting photos are composed in an artistic and balanced way. There are many ways to improve your composition. Some easy ideas include: putting the main subject off-center, adding a foreground element, shooting through a window or door, embracing reflections, including shadows. Another way to improve your composition is to look at other photographers' successful smartphone images. You will see what looks good and you can apply elements you see to your own work. Checking out photos on Instagram and in online galleries is a great source of inspiration for me.

Post-Processing Is Fun

You can step up your smartphone photography by using post-processing apps. After you take a shot, use your smartphone's in-camera software to fine-tune your photo.

I make minor adjustments, like cropping, increasing contrast, and straightening the horizon line, to almost all my photos. That is the minimum work that I do. But the real fun starts for me when I open a creative app to enhance my images with selective adjustments and creative filters.

At the moment, my favorite apps on my iPhone are Snapseed, PS Express, Dramatic B&W, Prisma, and Distressed FX. Snapseed is free. The rest cost a few dollars each. You learn how to use these apps by spending time experimenting with your photos. The process is very creative and you can spend a lot of time immersed in your work. Photography apps are powerful tools that will make your images more eye-catching and make you feel more artistic.

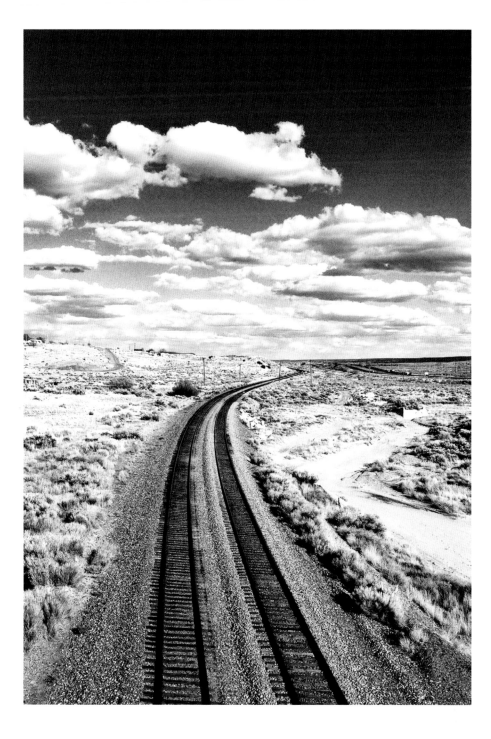

Enjoy the creative process. When you like what you see, post your images on social media. As you become more skillful, enter your work in online photo contests. Sharing images can be very satisfying and motivating for the ranks of savvy smartphone photographers!

PART II
ROUTE 66 ROAD TRIP

NEVADA

UTAH

Las Vegas

COLORADO RIVER

Grand Canyon National Park

Nelson

93 Chloride

66 Seligman

64

Hackberry

Kingman

Williams

Winslow

Joseph City

Holbrook

66

CALIFORNIA

ARIZONA

ALBUQUERQUE,
NEW MEXICO

The city of Albuquerque has much to offer photographers. There are vintage buildings and artistic murals in the downtown area and Southwest architecture mixed with Native American charm in Old Town. Albuquerque, founded in 1706, claims to be the oldest city on Route 66. More recently, this New Mexico town was the setting for the popular television show *Breaking Bad*.

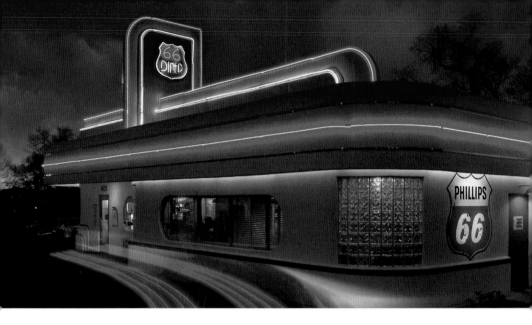

Grab a Great Bite

66 Diner

1405 Central Avenue NE
Albuquerque, NM 87106
505-247-1421
www.66diner.com

Perhaps there is no better place to start your Southwestern Route 66 road trip than the historic 66 Diner, which is equally enjoyable for breakfast, lunch, or dinner.

Walking through the front door is like stepping back in time to an era when life was simple, when pop music was based on having fun and being in love (and occasionally on heartbreak)—and, of course, when we did not count calories. The specialties, which include chicken fried steak and the Elvis Peanut Butter and Banana Deluxe Shake, are served by friendly waitresses and waiters dressed in typical 1950s diner uniforms.

For a quick bite, perhaps order the New Mexico Green Chile Stew,

pick a swivel stool, and sit at the checkerboard counter. Got more time? Check out the back dining room, which is decorated with Route 66 and 1950s memorabilia: a gas pump, Betty Boop and Marilyn Monroe neon signs, and Formica-topped tables and vinyl covered chairs. Order the Steak Ranchero and you'll leave with a full belly. Order the homemade chicken salad and you'll have more energy for other nearby Route 66 experiences.

Outdoor Photo Tips

The diner looks very cool at night, when neon lights illuminate the art deco building. For hand-held shots, boost your ISO to perhaps 800 or 1000, with the goal of shooting at a shutter speeds that will give you a sharp shot.

You'll need a wide-angle lens to get the diner and some of the surrounding area, including the sky, in the scene. A wide-angle lens, when set at a small aperture, will also give you good depth-of-field, meaning that you'll get most of the scene in sharp focus.

And speaking of depth, try photographing the building from an angle, rather than straight on, for a picture with more depth and dimension.

If you have a tripod, which we recommend, you can shoot at a lower ISO for an image with less digital noise, resulting in a cleaner image.

Make sure the lights are not overexposed. Use your camera's Highlight Alert to ensure a correct exposure.

Nighttime Photo Tips

For a really fun shot, have your travel buddy drive a car though the diner's driveway and shoot when the car passes by so you record the taillights as illustrated by the image on the facing page

To create the streaking effect, you'll need to shoot at a slow shutter speed. Try exposures from 5 to 10 seconds. Rick made this exposure with his Canon 17–40mm lens set at 31mm. His settings: ISO 100, f/22, 3.2 seconds.

For this "really fun shot," please be careful and be aware of other cars. If you plan to take this shot wear white or, better yet, a reflective vest.

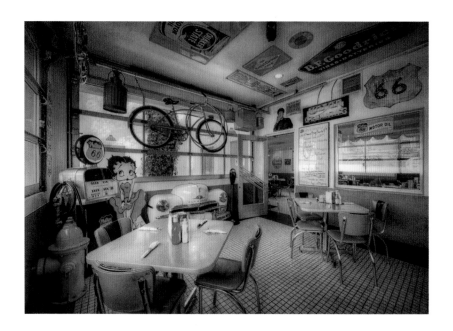

Indoor Photo Tips

Try to tell the whole story of the diner. Photograph the interior and the dressed-in-period waitstaff.

We recommend natural light photographs because a flash can ruin the mood of the scene. Due to the relatively low light, you'll need high ISO settings, maybe even as high as ISO 1600 for hand-held shots. As always, check your camera's LCD monitor by zooming in to see if you have a sharp shot. Reshoot if needed.

Of course, a tripod is a sure way to ensure a steady shot when making long exposures.

Wide-angle lenses will let you capture the feeling of the retro rooms. Again, shoot at an angle to create a sense of dimension in your photographs.

For people pictures, such as a waitress serving a shake at the bar or at your table, we recommend taking what I call "environmental portraits." These are pictures of the subject surrounded by their envi-

ronment. Lenses in the 35mm to 50mm range are recommended for environmental portraits.

When composing environmental portraits, check the background—it can make or break the shot. You don't want the straw of a shake being served by another waitress, for example, sticking out of your subject's ear.

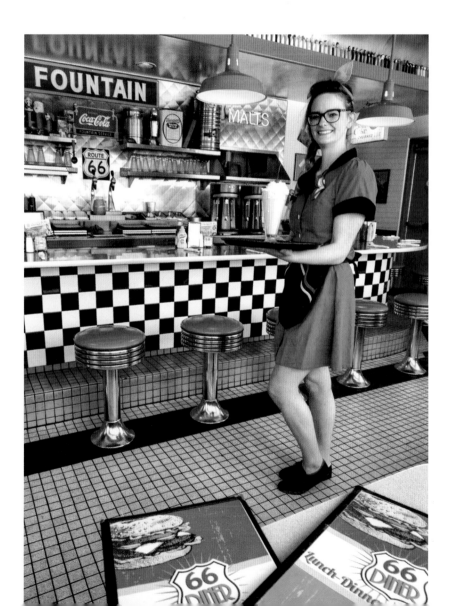

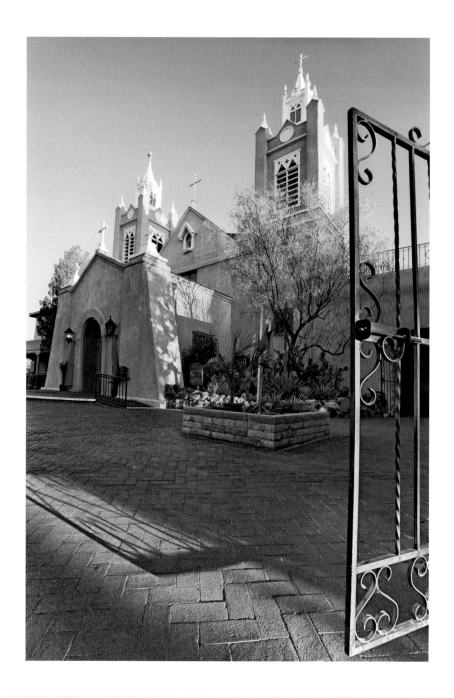

Say a Little Prayer

San Felipe de Neri Church
2005 North Plaza NW
Albuquerque, NM 87104
http://sanfelipedeneri.org

Old Town is the place to go to get the feel for an older Albuquerque, rich in history and religion. The San Felipe de Neri Church, built in 1793, is the centerpiece of Old Town and can't be missed on your road trip.

We have been to the church three times, each time in the early morning. Services begin early, with a mass starting at 7 a.m. If you want to get photographs without people, you need to get up extra early.

Another advantage to getting up early is that you can park for free on the streets. Later on in the day, if you can't find a space, you will need to pay for parking at one of the public parking lots.

Photo Tips

The church is beautifully illuminated in the early morning, when soft shadows accent the beautiful structure.

Bring your wide-angle zoom lens. Shoot by the gate at the left side of the church and use a small aperture to get the entire scene in focus. Rick set his Canon 16–35mm lens at 16mm to capture a very wide area of the scene. An aperture of f/8 provided enough depth-of-field to get the entire scene in sharp focus.

If the shadows are too strong, and you don't see enough detail in those areas, try HDR photography, described in **Rick's Quick Photo Tips for Route 66** section on page 29.

You don't need a high-end digital camera to get a nice image of the church. Susan took this shot and processed it with Snapseed for an artistic effect. You will find more photo tips in **Susan's Road Trip Photo Tips** section on page 57.

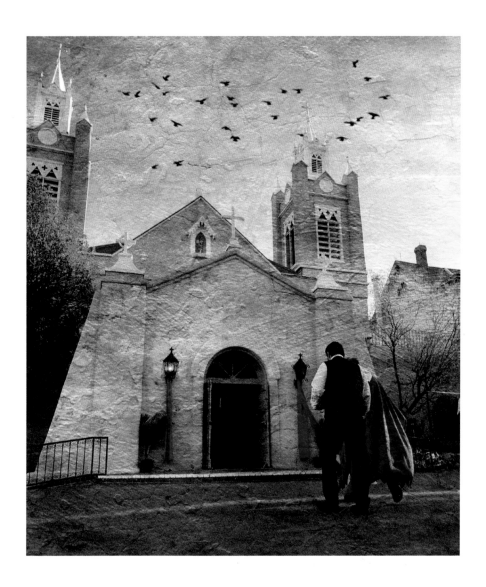

Once Old Town wakes up, you can have a meal in one of the many restaurants that line the town square or do some shopping.

When we were in the town square on Palm Sunday weekend, a local band was playing Spanish-style music while residents and tourists danced and enjoyed the festivities.

Nighttime is the Right Time for Neon

Absolutely Neon
3903 Central Avenue NE
Albuquerque, NM 87108
www.absolutelyneon.com

Robert Randazzo, neon light artist and owner of Absolutely Neon, is a character—one of the nicest characters we met along Route 66. He's been making neon signs for hotels and business along Route 66 and other locations for many years. Swing by his shop for an up-close and personal look at neon artistry. Contact him in advance through his website.

Indoor Photo Tips

Robert is a busy guy and he may not have time to pose for photos. If he does, test your composition and exposure before he steps into position.

Due to the high contrast, you'll need either HDR (and Robert will need to hold very still) or you will need to use a flash.

Nighttime Photo Tips

We used the same technique we used for our 66 Diner shot for this outdoor photograph of Robert's shop. Susan drove our rental car in front of the building for the long exposure.

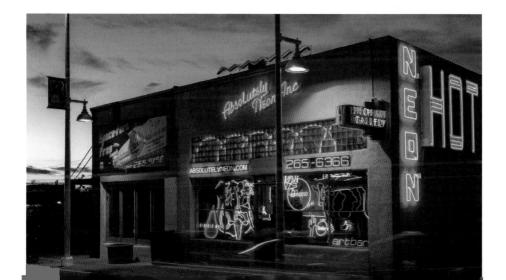

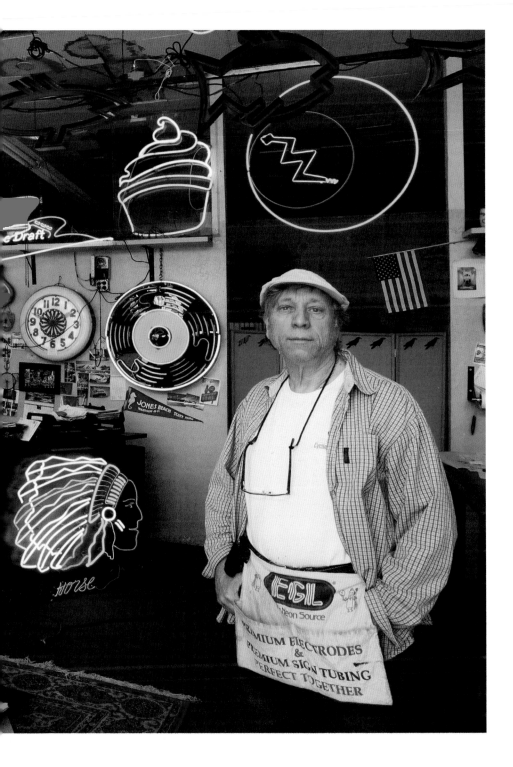

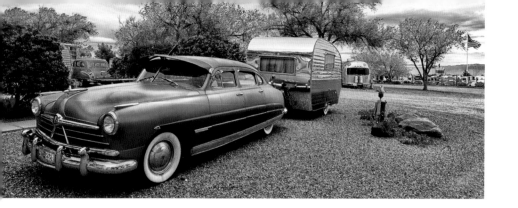

The RV Park Rocks

Enchanted Trails RV Park and Trading Post
14305 Central Avenue NW
Albuquerque, NM 87121
www.enchantedtrails.com

When you turn into the driveway of Enchanted Trails RV Park and Trading Post, which is actually on Historic Route 66, it's like you are turning the clock back to the 1940s when the trading post was established.

You can rent a space to park your RV here or even book a stay in one of the park's retro campers.

When you are in Albuquerque you can't miss this RV park, which is only about a 10-minute drive from Old Town. In addition to exploring the retro RVs, you can explore the Trading Post, where you will find retro TVs and other 1940s and 1950s memorabilia.

Photo Tips

Every picture tells a story and you can tell a wonderful story of a bygone era by taking both wide-angle and close-up photographs.

When taking wide-angle shots, use a wide-angle lens and small aperture to get the entire scene in focus—just as it looks to your eyes.

When taking close-ups, watch the background and try to isolate subjects and elements in the scene.

Cool Hotel

Hotel Andaluz

125 2nd Street NW
Albuquerque, NM 87102
www.hotelandaluz.com

Sure, you can stay at a Best Western or Hilton Garden Inn, but if you have a few extra bucks check out the Hotel Andaluz, which was the oldest Hilton Hotel in the United States at one time. The rooms and lobby are romantic and the hotel's restaurant, Mas, offers excellent gourmet food. We loved the grilled artichokes, olives and grapes, tuna nachos, and shrimp special.

Photo Tips

The lobby of the hotel is worth photographing—and worth getting up very, very early before people start to check out.

The light is very low, so you will definitely need a tripod and definitely need to shoot HDR to capture all the detail in the highlights and shadows of this beautiful lobby.

Rick captured the wide view here with his Canon 16–35mm lens.

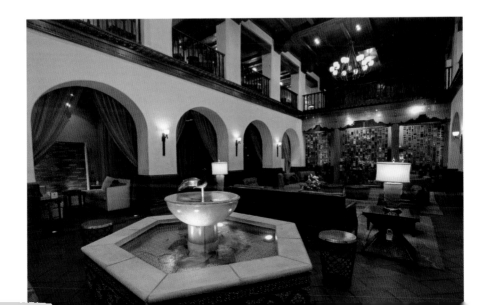

Restaurant Recommendation

Garcia's Kitchen
1736 Central Avenue SW
Albuquerque, NM 87104
http://garciaskitchen.com

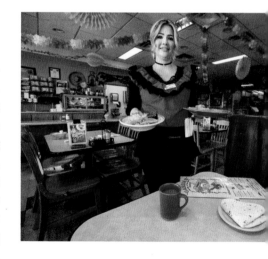

You can't leave town without having breakfast at Garcia's Kitchen. We had the huevos rancheros and breakfast tacos served by a friendly waitress who was willing to help us out with a photograph. The coffee was great, too—so good that we bought a Garcia's Kitchen coffee mug to bring back memories of our experience long after pulling off historic Route 66.

Photo Tip

Have your camera ready to photograph your server. People pictures make a road trip gallery or book come alive.

Extension Trip Ideas: The Albuquerque International Balloon Fiesta is a held every October. This is a high-flying photographic special event. If you are planning a fall road trip, this is a stop you might want to add to your itinerary. Find more information on the fiesta's website: www .balloonfiesta.com/index.php.

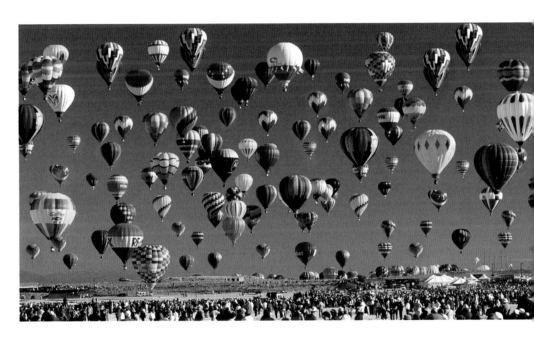

Next Stop: Route 66 Auto Museum in Santa Rosa. Drive time from Albuquerque to Santa Rosa is 1 hour 45 minutes.

SANTA ROSA AND TUCUMCARI, NEW MEXICO

Santa Rosa and Tucumcari are only about an hour away from each other, so we decided to group both locations into one chapter.

Santa Rosa really has only one cool stop for a photo op: the Route 66 Auto Museum. It's on your westward Route 66 road trip, so you really should make the detour.

Tucumcari, on the other hand, is rich with photo possibilities. Motels, murals, signs, and neon line the main drag in this sleepy New Mexico town. In fact, it's in Tucumcari that you will find perhaps the most iconic landmark of historic Route 66: the Blue Swallow Motel.

We stopped at Santa Rosa on the way to Tucumcari, so let's "visit" that location first.

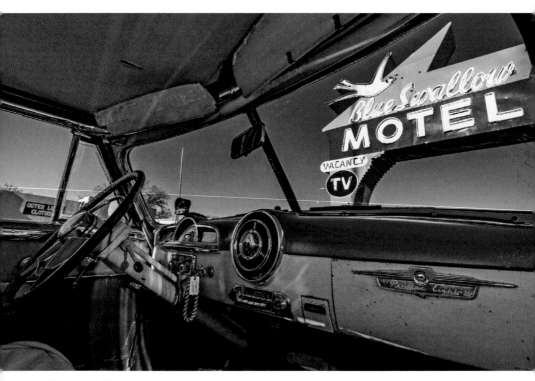

Tucumcari, NM

Go Back in Time on the Road

SANTA ROSA, NEW MEXICO

Route 66 Auto Museum
2866 Will Rogers Drive (Route 66)
Santa Rosa, NM 88435

In the 1950s and 1960s, when Route 66 was thriving, cars had unique personalities. Today, it's difficult to tell the different between a Hyundai and a BMW. So many cars look so alike.

A visit to the Route 66 Auto Museum takes us back to that bygone era of what are now known as classic cars. Here, dozens of well-restored classic cars are on display in near-perfect condition and some are even for sale.

The gift store at the Route 66 Museum has more memorabilia than it has classic cars and hot rods. If you are looking for a Route 66 jacket, shirt, hat, or mug, this is a good place to stock up on souvenirs.

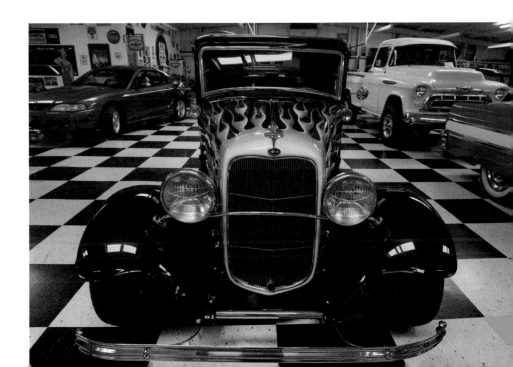

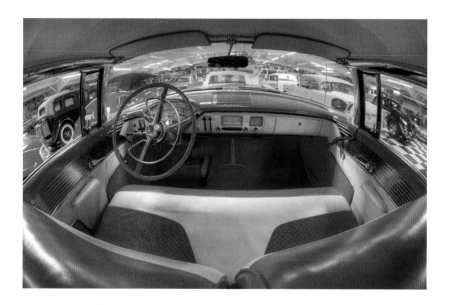

There's a snack bar, too, if you get the munchies. If you need something more substantial, there's a McDonalds just a few miles down the road to the east of the museum.

Photo Tips

Take both wide-angle and detail photographs. For unique views, ask the staff if you can get inside one of the cars for an inside-to-outside shot.

I used my Canon 8–15mm lens on my Canon 5D Mark IV for this shot from inside one of the old cars.

A panorama can help to tell the story of the museum, too. This is a six-shot panorama that Rick made with his Canon 16–35mm lens set at 16mm.

Watch for reflections that can often be reduced by changing your position.

For sharp hand-held shots, you'll need to boost your ISO, perhaps to ISO 1000 or higher.

Want to capture the accurate color of the cool cars? Set your camera's white balance to Fluorescent.

For your inside-to-outside shot and panorama, you will need HDR and a pano program, respectively. Both techniques are covered in **Rick's Quick Photo Tips For Route 66** section on page 29.

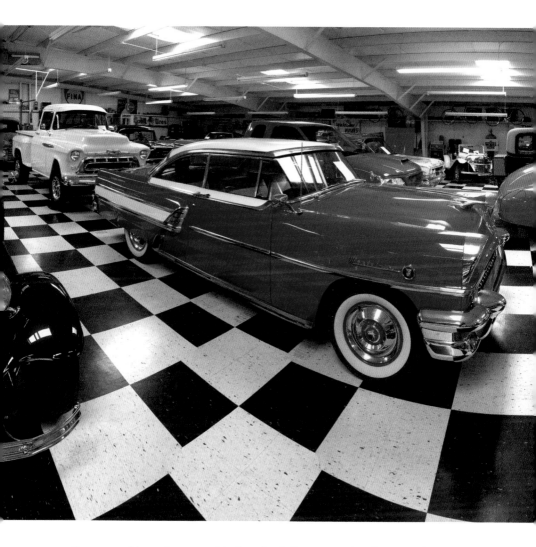

Sure, go wide and super wide, but don't forget to take close-up photos too. They help to tell the story of your visit.

Want to add a retro look to your photos of retro cars? Try adding a vintage effect in Snapseed, as Susan did for the photograph on page 93.

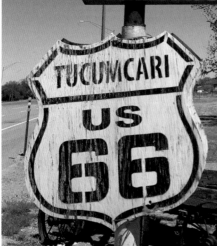

TUCUMCARI
TRADING
POST

ON ROUTE 66

TUCUMCARI

US

66

Don't Miss a Photo at the Trading Post

TUCUMCARI, NEW MEXICO

In Tucumcari, photographers will enjoy finding subjects that capture the past and present in both the abandoned buildings and restored businesses. We found a gift shop shaped like a giant teepee and a restaurant topped with a Mexican sombrero. Guess you never know what you will find. If you are looking for knowledge, the New Mexico Route 66 Museum, also found in town, is good place to peruse.

Trading Post on Route 66
1900 W Tucumcari Boulevard (Route 66)
Tucumcari, NM 88401

Take the first Tucumcari exit off I-40 on your way into town and you'll see the Trading Post on Route 66 on the right side of the road. You can't miss it.

Old Texaco and Mobil signs frame an old pick-up truck, and offer a nice frame for a photograph.

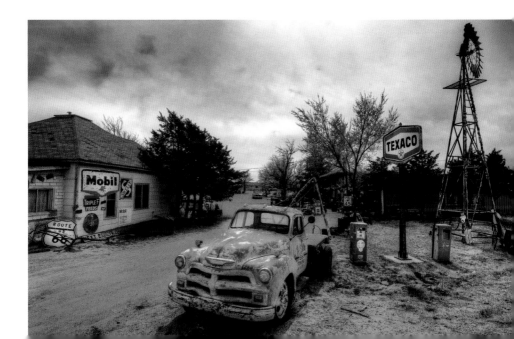

Photo Tips

The sun rises to the front-right of the trading post and sets behind and to the left of the main entrance. For an even exposure, the morning is the best time to photograph. For afternoon shots on sunny days, you will need HDR to capture all the details in the scene.

Overcast days are actually the best time, we feel, to photograph the trading post. When the sky is overcast, soft light illuminates the scene without harsh shadows.

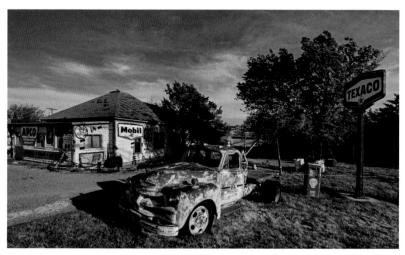

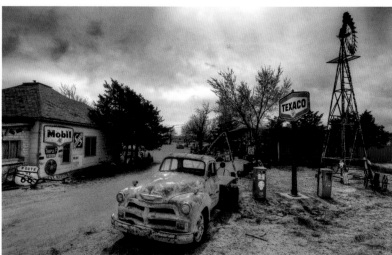

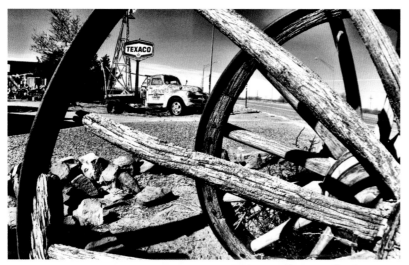

There are tons of photo opportunities at the trading post. Take both wide-angle and close-up photographs to tell the story.

When composing a scene, use what we call "border patrol." That is, run your eye around the edges of your viewfinder or LCD monitor to make sure that what you want is in the frame and what you don't want is not in the frame. Then consider how a scene can be improved with creative cropping.

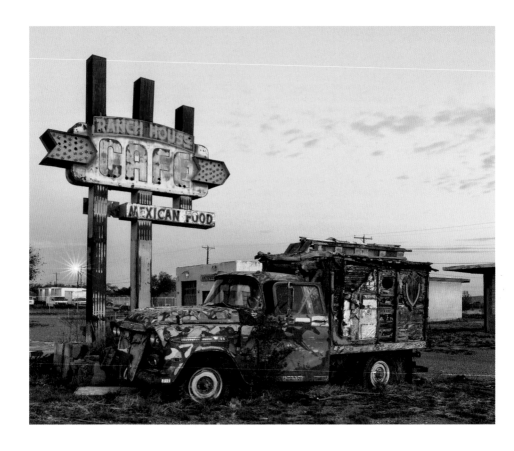

On the opposite side of the street you will find the abandoned Ranch House Cafe. The old sign and pick-up truck provide more nice photo opportunities.

We took this picture just before sunrise, when the light was soft.

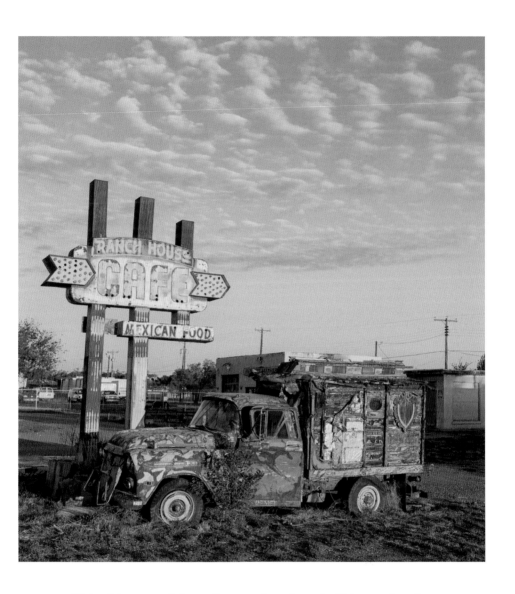

This picture was taken after sunrise when the light was harsh.

The two pictures illustrate an important photographic concept: Light affects the mood and feeling of the scene.

Photograph the Blue Swallow at the Blue Hour

Blue Swallow Motel

815 E Route 66

Tucumcari, NM 88401

575-461-9849

www.blueswallowmotel.com

For many, the Blue Swallow Motel in Tucumcari, with its iconic neon sign and classic motel motif, is a road trip high point. Along with the Wigwam Motel in Holbrook, Arizona (covered later in this book), images of these two roadside wonders convey the history and spirit of Route 66 and should not be missed.

We not only photographed the motel, we stayed there too, booking the Lillian Redman Suite for one night. We were warmly welcomed by the motel's owners, Cameron and Jessica, who helped to make our overnight stay an enjoyable experience—one we highly recommend over staying at one of the chain motels near the I-40. Unlike many of the surrounding hotels, such as The Palomino Motel, the Blue Swallow was fully booked.

The Blue Swallow Motel, opened in 1940, is on the National Register of Historical Places. Our feeling is that the ambiance of the location has not changed much over the years. Upon seeing the building, especially at night, you feel as though you have taken a time machine back to when Tucumcari was a thriving tourist destination.

Photo Tips

Our pictures of the Blue Swallow are surely some of our favorites from our two Route 66 trips. We have photographed the motel before sunrise, at sunrise, and after dark. In all three situations, we've MADE pictures, with the help of the owner, rather than just TAKEN pictures. Here's what we mean.

We made the top picture on the next page about 15 minutes after sunrise. To get the starburst in the lamppost light on the right, Rick set

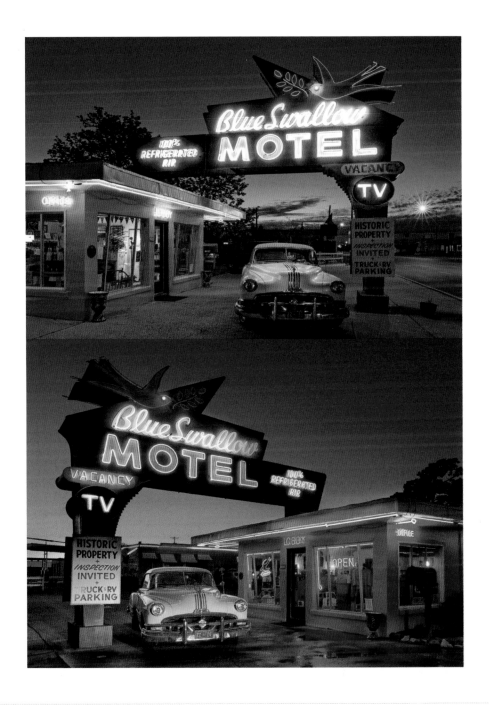

his Canon 17–40mm lens at 17mm and shot at f/22. The night before, we asked the owner to move his vintage car, which actually still runs, into the position you see here.

We made the bottom picture just after sunset. We used a garden hose to wet the driveway to add some reflections to the scene. Here, too, we worked with the owner to move the car into position. To add some light on the vintage car, we moved our rental car into position and turned on the headlights.

The after-sunset and pre-sunrise photographs were taken with Rick's Canon 5D Mark IV camera mounted on a tripod using his Canon 16–35mm lens, which was his go-to lens for Route 66.

The two previous photographs are in-camera HDR images with the exposure set to EV 0, EV -2, EV +2. Rick takes you though the HDR process for this image in his **Rick's Quick Photo Tips for Route 66** section on page 29.

After you have photographed the centerpiece of Tucumcari, take a walk up and down Historic Route 66. You will find many buildings that represent the bygone era. Experiment with making black-and-white

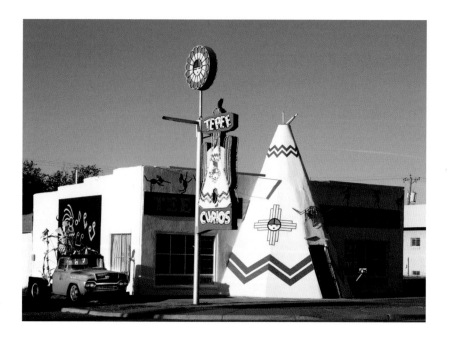

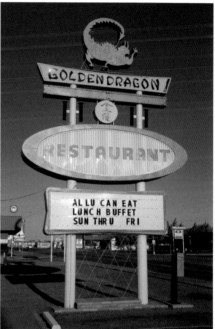

images from your color files. When you shoot from the street, watch for speeding cars. A driver's vision can be hampered by the strong sunlight.

Try photographing both into the sun and with the sun at your back. As this pair of pictures illustrates, the direction of light makes a big difference.

When shooting into the sun, check your camera's Highlight Alert feature to make sure bright areas are not overexposed and washed out. HDR can work here, too.

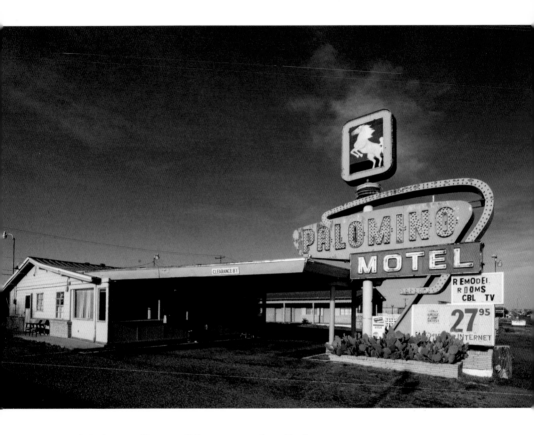

Make a Great Photo at the Palomino

Another iconic motel in Tucumcari is the Palomino. You might want to grab a shot of it during an early morning or late-afternoon walk (when this picture was taken). The rooms are only $27 a night.

Restaurant Recommendations

Tucumcari is not a big food town. Some of the chain fast-food restaurants are located near the I-40 ramp. We enjoyed a burger with the locals at K-Bob's Steakhouse and had a typical diner breakfast at Kix on 66, conveniently located across from the Blue Swallow Motel.

K-Bob's Steakhouse
200 E Estrella Avenue
Tucumcari, NM 88401
575-282-5262
www.k-bobs.com/location/new-mexico

Kix on 66
1102 E Route 66
Tucumcari, NM 88401
575-461-1966
www.kixon66.com

Okay, now it's time to get back on I-40, traveling west.

Next Stop: Santa Fe. Drive time from Tucumcari to Santa Fe is 2 hours 35 minutes.

SANTA FE,
NEW MEXICO

Santa Fe is a city loved by artists, art lovers, thinkers, and spiritual guidance seekers. Known for its beautiful natural light, Santa Fe welcomes visitors with its warm-toned adobe walls, accentuated by a dramatic blue sky and white clouds.

The city is also rich in Spanish and Native American history, reflected in historic chapels and churches. You do not want to miss Santa Fe on your Route 66 road trip.

Santa Fe is New Mexico's capital city, offering greater opportunities for lodging, food, and excursions than most of the smaller towns we visited on Route 66. The downside of being in a bigger city is that you will encounter more traffic and the restaurants can be crowded.

Traveling to Santa Fe might seem like a detour from Route 66, as it takes you about an hour off I-40 outside Albuquerque. Actually, the original plan for Route 66 included Santa Fe on the map. It was political payback in the 1930s that motivated an outgoing governor to re-route Route 66 and bypass the city.

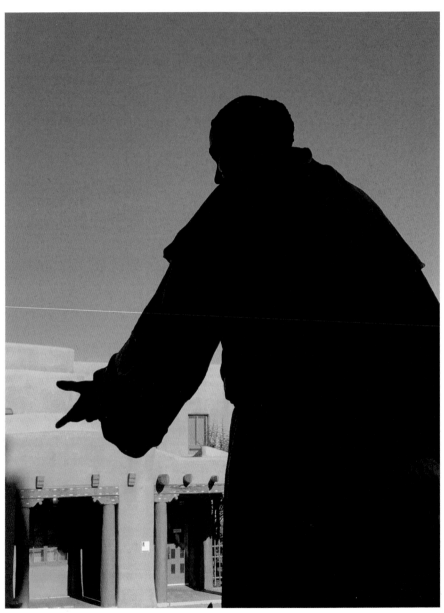

It's fun to shoot silhouettes in the early morning and late afternoon in Santa Fe

Relax at El Rey

El Rey Inn
1862 Cerrillos Road
Santa Fe, NM 87505
505-982-1931
www.elreyinnsantafe.com

There is no shortage of places to stay in Santa Fe, from luxury hotels to chain lodging. But for Route 66 photo trippers, we recommend staying at the El Rey Inn, just a short ride from the center of the city. As soon as you arrive you will know why we like it so much. El Rey, directly on Route 66, is an oasis that mirrors the feeling of what people call "The Mother Road." It's an upscale, vintage motel (more like a nice house with private rooms) decorated with Southwestern-style furniture, art, and antiques. The grounds feature outdoor spaces that invite photographers to capture the gardens and architectural details.

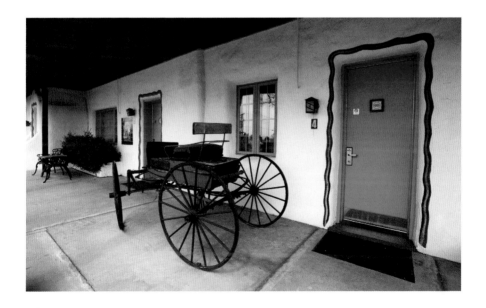

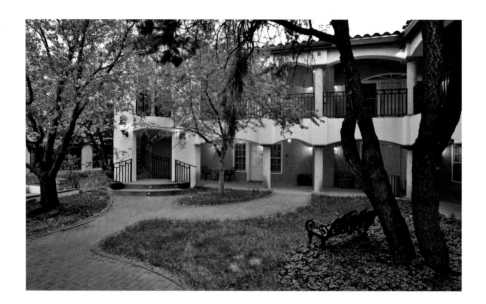

Photo Tips

The rear courtyard is the most picturesque part of the complex. To capture the romantic mood of El Rey, we photographed at dusk when there was a bit of light in the sky and when the building lights were turned on.

In this photo, Rick used HDR to capture the dynamic range of the scene while using the flowering trees and winding brick path to frame the tower with the spiral staircase that led up to our room.

The entire area of El Rey is photogenic, so shoot with your wide-angle lens to capture all the romance.

Chasing Shadows in The Plaza

The Plaza

www.santafenm.gov

To stroll around the The Plaza is to stroll back in time. This area was the seat of the Spanish government in the early seventeenth century, and nearby churches and chapels date back to that time as well. If you're

familiar with the movie *Zorro*, The Plaza will seem like a scene right out of the tales of that masked avenger.

Buildings around the plaza embrace a similar Spanish-style of architecture, with soft-curved adobe walls and beams and wooden window-frames and doors. As you walk around, you will see how the changing light saturates colors and deepens shadows. Rooflines and the shapes of buildings present wonderful contrast against the clear blue sky. This is a shopping center, too. Local Native Americans display their crafts on the sidewalks while upscale clothing stores and art galleries line the perimeter of the plaza.

Photo Tips

Light illuminates, shadow defines. Photographing in The Plaza offers a wonderful opportunity to illustrate this time-proven photo adage.

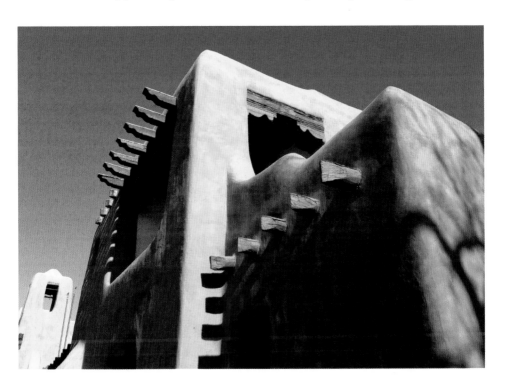

Go to Church

There are many churches to visit in Santa Fe. A trio of these historic buildings are close together so you can park and walk to all three. Plan your visit to see the outside entrance areas during warm morning or afternoon light. Check what time the churches open when you are in town, as posted times vary.

Loretto Chapel
207 Old Santa Fe Trail
Santa Fe, NM 87501
www.lorettochapel.com

The Loretto Chapel's claim to fame is "the Miraculous Staircase," a beautifully curved spiral that appears suspended without support. Loretto

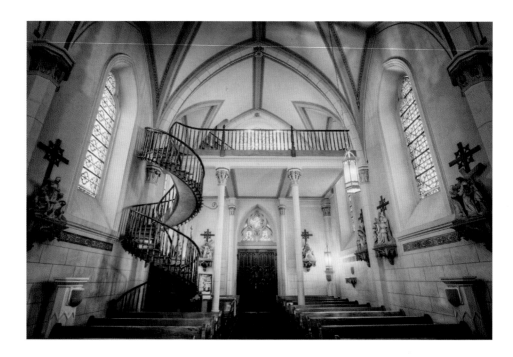

Chapel is no longer an active religious institution. Today it is a private museum used for weddings and other events.

Photo Tips

Our most important photo tip for Loretto Chapel is to get there half an hour before it opens and be first on line so you can be first in the chapel and the first to make a picture. This is important because the chapel is usually packed with people, including other photographers who want a shot.

We were first on line and, as the saying goes, "the early bird catches the worm." We made pictures that captured the beauty of the amazing structure before tourists with Route 66 T-shirts could get in the frame.

You can take a hand-held shot, but you'd need to boost your ISO to about 4000, so you may get some digital noise in your frame.

Rick used a tripod for this photograph, which let him shoot at ISO 500.

As with several of our indoor shots, this is an HDR photograph comprised of seven exposures that were processed into his final HDR image. He used his 16–35mm lens to get as much of the chapel in the frame as possible. To enhance the beauty of the scene, Rick made a sepia tone image in Lightroom.

San Miguel Chapel

401 Old Santa Fe Trail
Santa Fe, NM 87501
505-983-3974
www.sanmiguelchapel.org

San Miguel Chapel is a church with bragging rights. It claims to be the oldest church in the United States, dating back to the 1600s. It is an inviting Spanish-style structure with classic adobe design. The inside is like a museum with many paintings, carvings, and statues to discover and photograph.

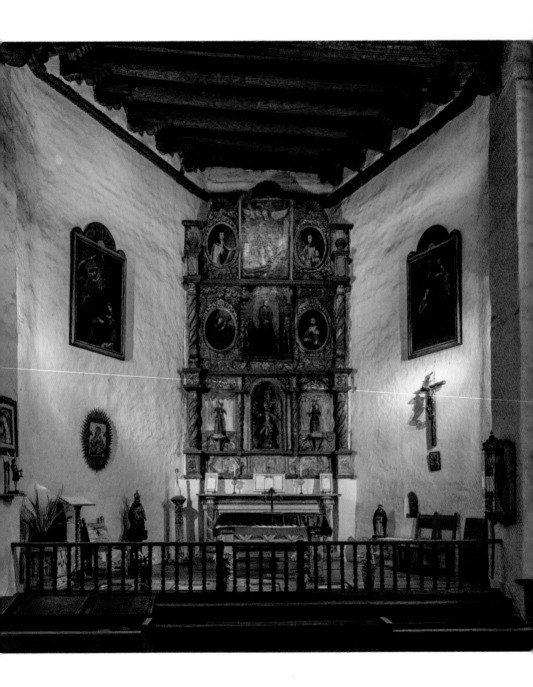

Photo Tips

Our photo tips for San Miguel Chapel are basically the same as for Loretto Chapel. The main difference between the two is that San Miguel Chapel is darker than Loretto Chapel. So if you take hand-held photographs, you will need to boost your ISO for a steady shot.

Take some close-up shots, too. They help to tell the story of this wonderful chapel.

Cathedral Basilica of St. Francis of Assisi

131 Cathedral Place
Santa Fe, NM 87501
505-982-5619
http://cbsfa.org

The Cathedral Basilica of St. Francis of Assisi is another must-see sight in Santa Fe. Beautiful statues are found near the entrance area and the cathedral doors are a work of art. Walk around this impressive structure to find unique architectural angles set against the crisp New Mexico sky.

Photo Tips

Susan has a good eye for details and detail/close-up shots help to tell a story of a location. Here's one of Susan's photographs of a section of one of the church entry doors.

And on the next page is a wide-angle shot of the outside of the basilica. The church is framed by the trees, which, as illustrated by other photographs in this books, give a sense of "being there" to the photograph.

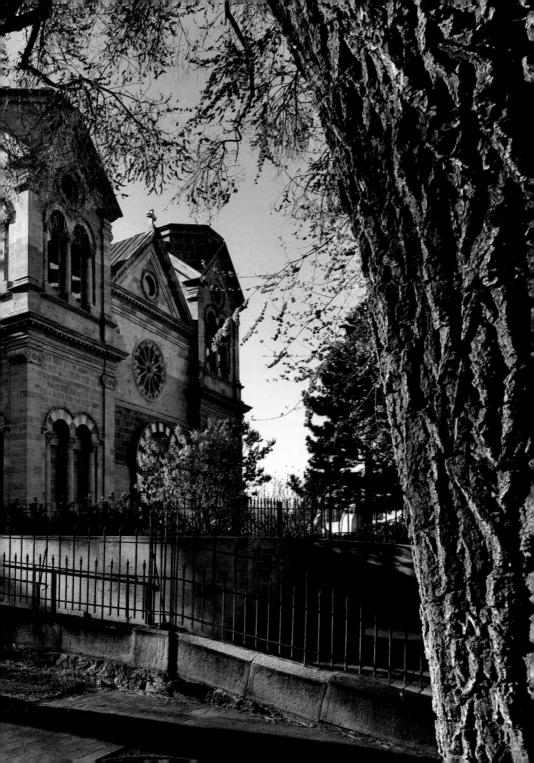

Hike at Tent Rock

Kasha-Katuwe Tent Rocks National Monument

Jemez Springs

Cochiti Pueblo, NM 87025

505-331-6259

www.blm.gov/nlcs_web/sites/nm/st/en/prog/NLCS/KKTR_NM.html

To balance the busy energy of the city, take a ride to Kasha-Katuwe Tent Rocks National Monument. It's about a 45-minute ride from the center of town. The name Kasha-Katuwe means "white cliffs," and "tent rocks" perfectly describes the cone-shaped rock formations found here. Great hiking trails lead around hoodoos (rock formations carved by wind and rain) and through narrow slots. Double check the hours before you go, as the park's closing time varies by season. Be prepared to pay an entrance fee, and bring your own water and snacks—there are no services here.

Photo Tips

Tent Rocks, with its unusual rock formations, is a great location for landscape photography. It's also a fun place to take lifestyle photographs—hiking, in this case.

Because it's at least a 1-hour hike from the parking lot to the start of the best photo spots, and because you will need to hike back, we recommend taking only one lens, a zoom with a range of about 16–35mm. That range will let you capture both landscape and lifestyle photographs. Of course, you can also tell the story with your smartphone, as Susan did.

As always, try to take one shot that "says" the location. Susan's shot on pages 124–125 does just that.

Look for tighter views of the fascinating rock formations while you are hiking. Use foreground elements to add a sense of depth to an image and use main subjects (the tree and small tent rock here) as focus points of your photograph. Set a small aperture on your wide-angle lens to get the entire scene in focus.

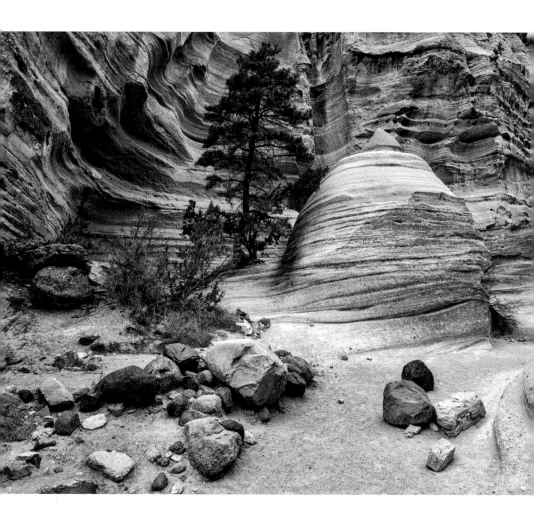

When processing your landscape photographs, you can take a page out of Ansel Adams's book and darken the edges to draw more attention to the scene.

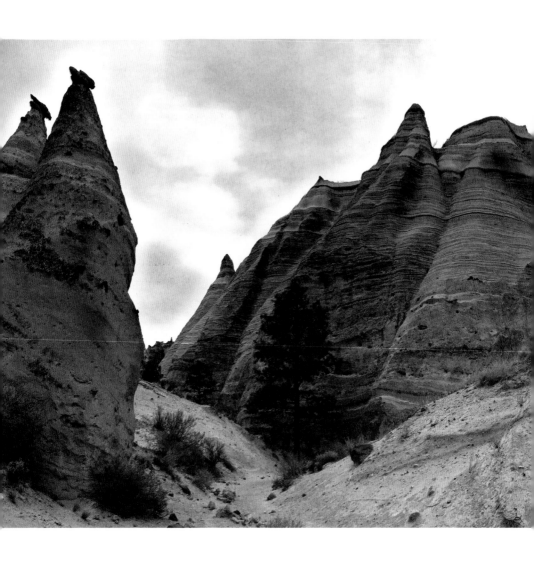

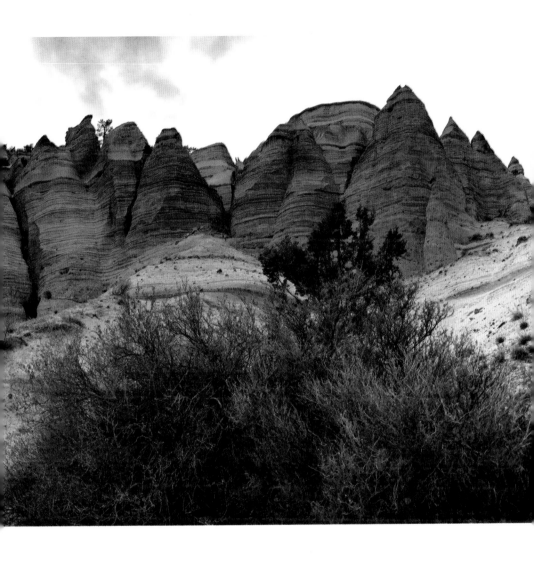

Lifestyle pictures add a sense of scale to a scene. Here the four hikers illustrate the size and scale of this section of Tent Rocks.

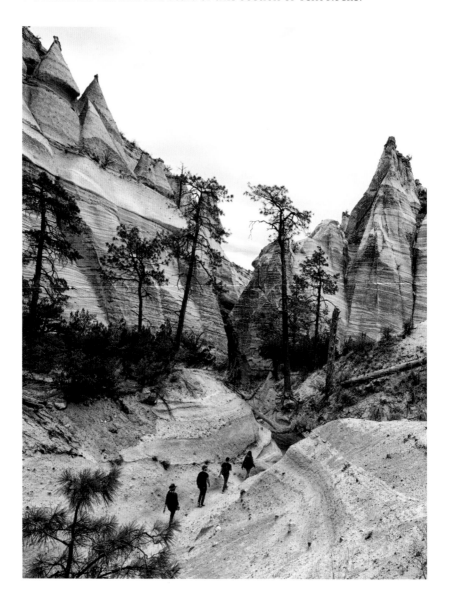

Restaurant Recommendations

The Pantry
1820 Cerrillos Road
Santa Fe, NM 87505
505-986-0022
www.pantrysantafe.com

Good news for food lovers: Santa Fe is a great food destination. If you are getting a little tired of diner fare and fast food, get ready to experience some real New Mexico cuisine. There's even more good news if you are staying at the El Rey Inn. Our breakfast and lunch recommendation is The Pantry, a friendly and busy local spot a short walk from the Inn. You'll find a mix of classical regional dishes, along with a few unique items like the blue corn cinnamon pancakes we ordered for breakfast.

For dinner we have two favorite places, one in town and one a little ways out. You'll get to feel like a local when you eat at Maria's. You will probably get to wait like one, too. Take the time to sample their made-

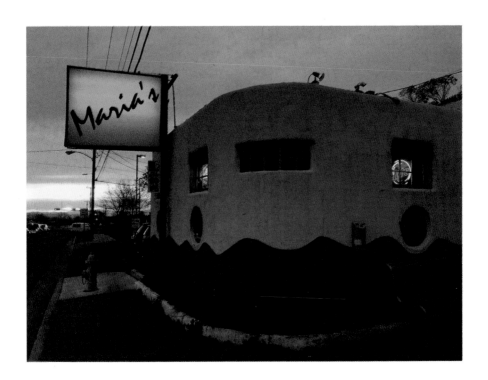

to-order margaritas. This restaurant features traditional northern New Mexico cuisine. Many dishes are served with freshly baked sopaipillas. Get ready for the big question of the night . . . red chili or green chili? If you are not sure, you can ask for a sample of both on the side.

Maria's New Mexican Kitchen
555 Cordova Road
Santa Fe, NM 87505
505-983-7929
http://marias-santafe.com

If you are in town by the plaza, drop by The Shed for dinner. There is a welcoming flagstone courtyard in front of the restaurant's rambling

dining rooms. The Shed's menu presents northern New Mexico dishes that mix Pueblo, Spanish, and Mexican influences, along with classic regional fare. Best to make a reservation, as this place can get busy. But, don't worry if you have to wait: The margaritas menu is extensive, and sipping your choice of beverage on the colorful patio is a delight.

The Shed
113½ East Palace Avenue
Santa Fe, NM 87501
505-982-9030
https://sfshed.com

Next Stop: Gallup, New Mexico. Drive time from Santa Fe to Gallup is about 3 hours.

GALLUP,
NEW MEXICO

Gallup is a small town with wonderful Western flare and a center for Native American culture. There's action here, too, as trains with bright orange loco-motives cut right through the town and hot air balloons can be seen sailing over beautiful rock formations. Photo opportunities for dramatic landscapes are found in nearby Red Rock Park. You'll find a winning combination of his-tory, culture, and nature in this sunny New Mexico town.

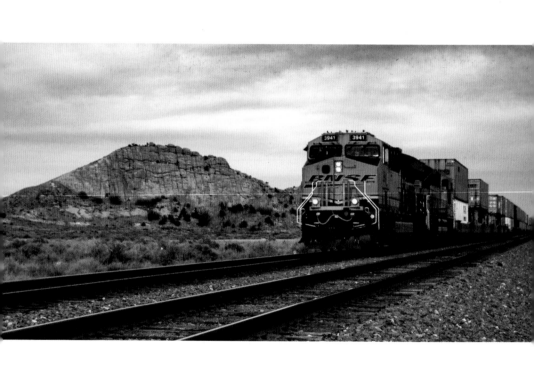

A Popular Spot for Movie Stars

El Rancho Hotel
1000 E Route 66
Gallup, NM 87301
505-863-9311
www.route66hotels.org

Soon after you exit I-40 to pick up Highway 66 in Gallup, you can't miss the historic centerpiece of this town, El Rancho Hotel. This charming wooden hotel was built with an Old West design, which is why we chose to stay there.

During the golden age of Route 66, the hotel was a popular stop for travelers on their westward journeys. According to the hotel's website, it was also a favorite spot for movie companies filming in the area. You will find a long list of famous Hollywood actors and actresses who stayed here on the hotel's website. This roster (which details more than 100 celebrity guests) includes Burt Lancaster, Errol Flynn, Gregory Peck, W. C. Fields, and Jane Fonda. If you use your imagination, you can imagine seeing these stars in the lobby.

Today, the building is like a frontier museum, with plenty of Western decor, beautiful Indian rugs, and walls full of movie memorabilia. In fact, the main lobby even looks like a movie set, with two hand-carved stairways leading to an open, wood-accented, second-floor balcony. It is worth the time to take a look around at the details here, and it's good fun to actually stay at the hotel. Even if you don't stay here, check out the hotel lobby. The restaurant, bar, and gift shop are all worth a stop, too.

If the hotel is booked, or if you want more modern accommodations, there is a Best Western directly behind the hotel and a Fairfield Inn and Suites just down the road.

Photo Tips

Our best photo tip for El Rancho is this: Don't miss photographing the lobby.

You will find the best vantage points from the balcony that overlooks the lobby. Due to the low light and high contrast range of the scene, you will need HDR, which Rick covers in **Rick's Quick Photo Tips for Route 66** section on page 29.

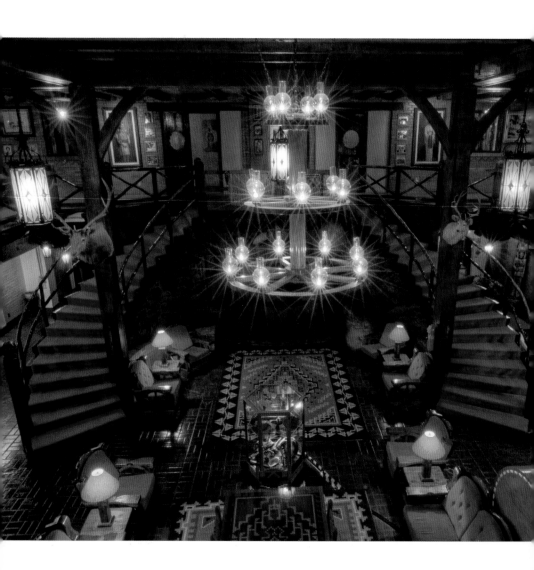

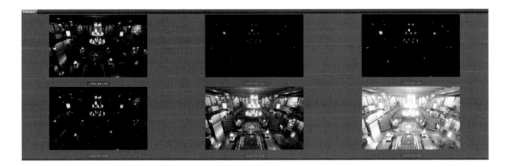

Here are the six images that Rick used to make his final HDR image. As you can see, six images were needed to capture all the shadow and highlight detail in the scene—details that when combined in Photomatix (Rick's favorite HDR program) were visible in the final image.

Set up your camera with wide-angle lens (set at f/16 for good depth-of-field) on a tripod on the balcony opposite the stairways and . . . wait. Wait until there are no people in the lobby. Your picture may look a bit lopsided, but in reality, the structure does not have straight angles in all locations.

Stay still while you are taking your series of pictures. If you move, your motion may shake your camera during your long exposures (due to the low light) because the floor moves just a bit when you move. So our advice is as follows: Steady as you shoot.

Shop at Richardson Trading Company

Richardson Trading Company
222 E Route 66
Gallup, NM 87301
505-722-4762
www.richardsontrading.com

The Richardson Trading Company is more than a store. It's an art gallery, museum, and bank of sorts—local cowboys and ranches "bank"

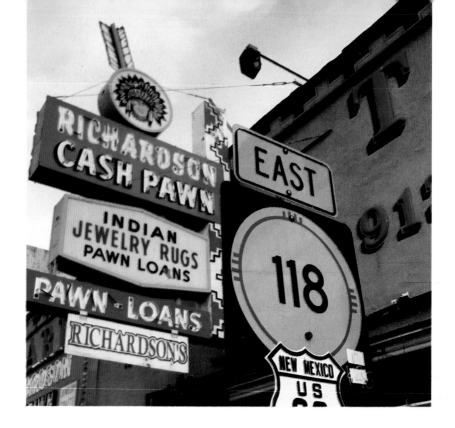

their saddles during winter months for use when the weather warms up. During our most recent visit, we saw more than 100 saddles in the "bank."

Several generations have built this family business into a bustling crossroads for the Gallup community. American Indian culture is on display here, from Navajo rugs to Kachina dolls. Western saddles, blankets, and turquoise jewelry are on display, too. The salespeople are friendly and happy to share their knowledge.

After our saleslady gave us an inspiring talk about how the Navajo women weave their colorful and impressive one-of-a-kind rugs, she introduced us to Mr. Richardson himself, who passed away in 2017. Stop here to experience a unique store and enjoy the visual inspiration. While you cannot take photos of individual pieces, you can ask to take shots of the some of the displays.

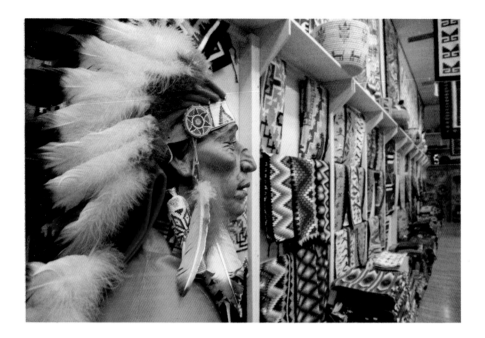

Our most recent trip to Gallup was our third. On our first two trips we missed Richardson Trading Company. We have our local friends John and Jo Van't Land to thank for showing us this wonderful, not-to-be-missed location.

Photo Tips
We found the main photo opportunities inside the building. For quick hand-held shots, boost your ISO. Rick took his shots with the ISO set at 2500. Susan used her iPhone, which automatically adjusts camera settings.

Photograph at an angle to add a sense of depth to an image and take both wide-angle and close-up shots. If you want to travel light, choose a lens with a focal length of around 24–105mm.

If you are serious about capturing the true color of the rugs, set your white balance to Fluorescent, since that is the type of lighting used inside the building.

If you see something or someone you want to photograph, ask first.

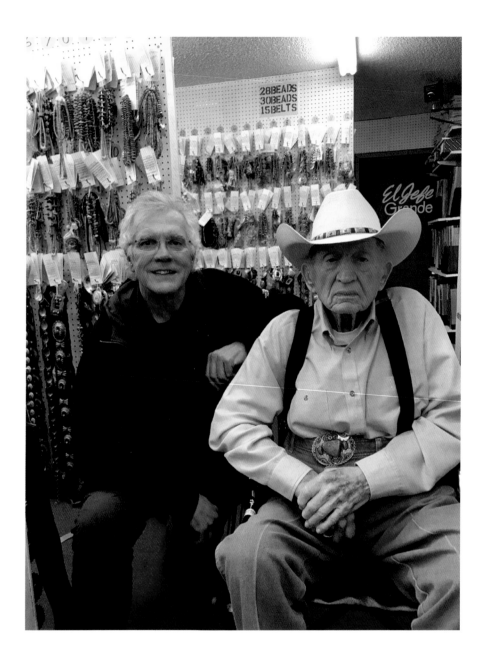

Stop for Trains

Colorful freight trains pass through Gallup throughout the day—every 30 minutes or so by our informal count. If you are on Highway 66, there are plenty of places to pull off both in town by Richardson Trading and on the road heading east toward Red Rock Park. Our favorite spot on a recent trip was across from the Hacienda Motel on Highway 66. The location presents a good vantage point to capture train action with nice mountains in the background.

Photo Tips

We photographed the trains on a previous trip to Gallup, but we had the most fun on our most recent trip—mainly because we were photographing with our friends John and Jo Van't Land.

Why was it so much fun? John let Rick stand on his SUV to get exactly the shot he wanted. Now, that's a good friend!

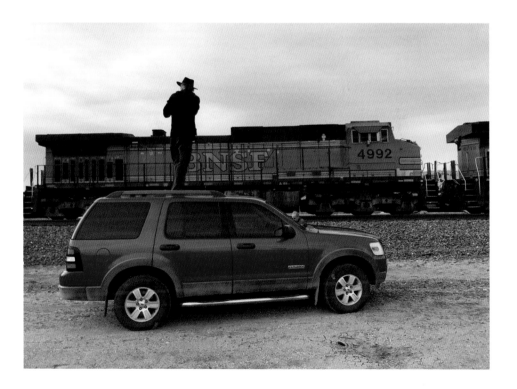

The higher angle let Rick eliminate the foreground for a cleaner photograph. So the tip here is to use careful composition. Only include what you want in the scene, and don't include what you don't want.

In Rick's shot on page 132, also notice how the tracks lead you toward the train. This is called using "leading lines" in the composition.

Also, try to include some of the rocks in Red Rock Park in the background. If you just take a close-up photo of the train, it will not "say" Gallup or Route 66.

Because the trains are moving, set your focus to focus tracking, which tracks the subject right up to the moment of exposure, for a sharp shot.

Above all: Safety first. The trains run in both directions, so always be on the lookout for another train—as well as another photo opportunity. Yes, you can get very close to the tracks, but don't get so close that you are taking a chance on getting hurt . . . or worse.

Take a Hike at Red Rock Park

Red Rock Park
825 Outlaw Road
Churchrock, NM 87311
505-722-3839
www.gallupnm.gov/207/Red-Rock-Park-and-Museum

As you drive east to west along I-40 in the Gallup area, you will start to see some wonderful rock formations out the window on the passenger's side of your car. These are the dramatic red cliffs and unique rock formations of Red Rock Park, just a 15-minute drive from the center of Gallup.

You will find many image-making opportunities here. We went early to capture the warm morning light and found lovely landscapes both in the park and on Route 566, running north of the park entrance. If you have time, there are good hikes to Church Rock and Pyramid Rock that

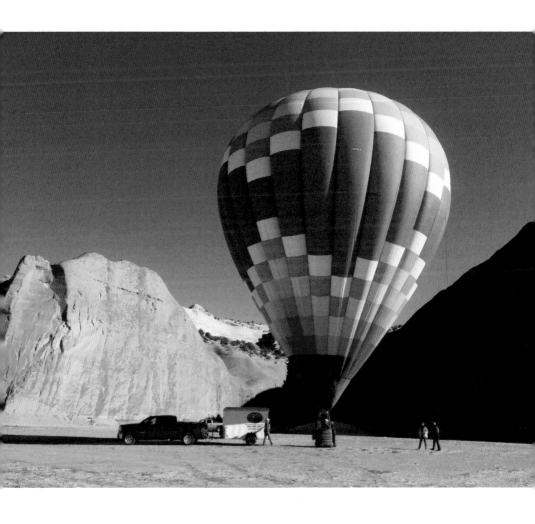

offer nice vistas. Keep your eyes out for hot air balloons, which can be seen floating about the ridges in the mornings.

Wear hiking boots, and don't forget your hat and water.

The park hosts many unique events during the year that can be wonderful for photography. There are junior rodeo competitions in the spring, the annual Inter-Tribal Ceremonial in August and the colorful Red Rock Balloon Rally in December.

Photo Tips

Red Rocks is where you will find endless landscape photo opportunities. This is wide-angle country, so you can take a hike with only your wide-angle zoom. That will make your trek on the trails more enjoyable, because you will not need to bring a heavy camera backpack filled with lenses.

Our one-lens recommendation is a zoom lens in the 16–35mm range.

One of our favorite photographs was taken around dawn. The picture below, in fact, was taken from the road at the entrance to the park

Midday is usually not a good time for landscape photographs unless you have dramatic clouds, as illustrated by the top photograph on the facing page. For a touch of creative processing, try making a black-and-white image. Boost the contrast a bit to darken the sky and lighten the clouds.

Before or after you photograph in Red Rock Park, take a drive along Route 566. This is where we took the bottom landscape photograph on the facing page. The photo tip here is to use separation when composing your photograph. That is, move around so that the elements in the scene are separated.

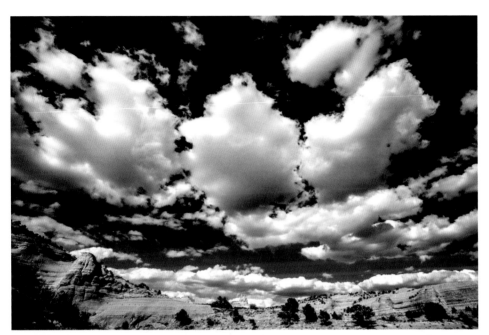

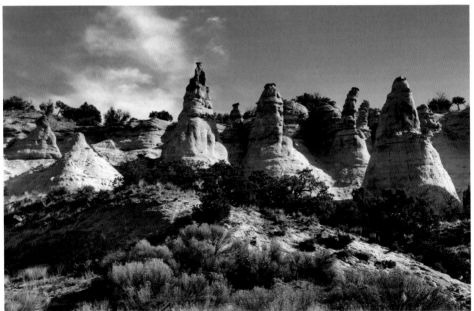

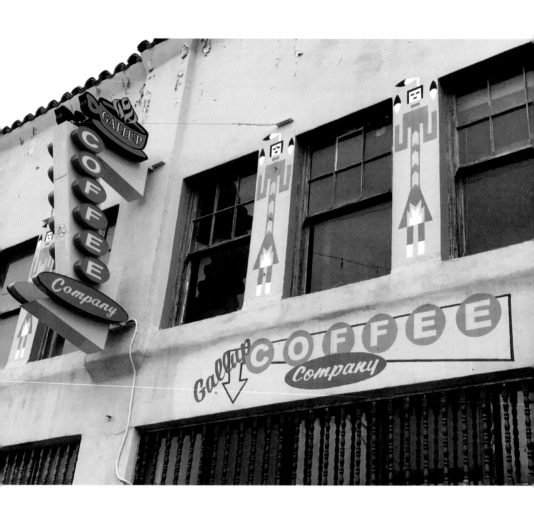

Restaurant Recommendations

Gallup Coffee Company

203 W Coal Avenue

Gallup, NM 87301

505-410-2505

Yelp listing: https://www.yelp.com/biz/gallup-coffee-company-gallup

If you want a break from huevos rancheros, make a short drive over to the Gallup Coffee Company. Coffee beans are roasted on site here, so brews are fit for serious coffee aficionados. The staff is super friendly and there is plenty of seating inside and out. Step up for a traditional coffee or espresso with a baked good or bagel, or go big with the duck and leek omelet.

Next Stop: A famous corner in Winslow, Arizona. Drive time from Gallup to Winslow is just under 2 hours.

WINSLOW AND HOLBROOK,
ARIZONA

Similarities and contrasts welcome visitors in the towns of Winslow and Holbrook. Both offer Route 66 staples like vintage cars, old motels, diners, and roadside attractions. But when it comes to accommodations, it is a tale of two cities. Winslow showcases a luxury property and Holbrook has a wacky lodging option. An easy drive connects the two towns so you can cover both places, along with a few photo stops in between, with one overnight.

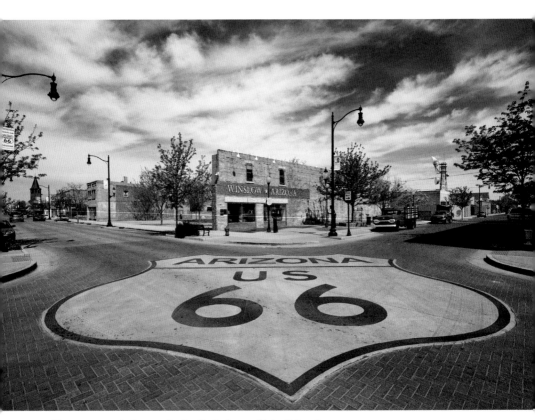

The corner made famous by the Eagles' song "Take it Easy"

Standing on a Corner

WINSLOW, ARIZONA

Most travelers make a stop in Winslow to photograph a corner of the town made famous by the line, "standing on a corner in Winslow, Arizona," in the Eagles' song, "Take it Easy." For sure, the recreated corner, which comes complete with a flat-bed Ford, is a wonderful photo opportunity.

Photo Tips

The best time to photograph the corner is in the late afternoon, when the façade of the building is front-lit. That is when we took the pictures you see here.

If you are only there in the morning, try HDR photography—or pray for clouds or an overcast sky that can reduce the contrast range of the scene.

Photograph the famous corner with your wide-angle lens. If you have a very wide-angle zoom lens, such as Rick's 16–35mm zoom, compose your scene with the Route 66 logo in the frame. Use a small aperture, perhaps f/8 or f/11, to get the entire scene in focus.

Got a smartphone? Don't forget to take a selfie. Shoot it off to a friend and tell them that you were standing on a corner . . . you get it.

La Posada Hotel & Gardens
303 E 2nd Street (Route 66)
Winslow, AZ 86047
928-289-4366
www.laposada.org

There is a delightful surprise waiting for you in Winslow: the La Posada Hotel. This masterpiece is one of the last of the Great Railway Hotels.

Mary Jane Colter designed the hotel. It opened in 1930 and was considered to be the finest hotel on Route 66. Staying at La Posada will take you back in time to an era when people traveled by train and enjoyed luxury accommodations along the way.

When train travel declined and Route 66 was bypassed, La Posada was forced to close. It was almost lost to the wrecking ball, but was rescued and then restored in the late 1990s. Today, La Posada welcomes visitors to enjoy this fabulous Spanish hacienda with its tasteful furnishings, original ironwork, and art galleries.

La Posada is a destination for taking both indoor and outdoor photographs. It's only two blocks away from the famous corner. It's where we stayed, and where we recommend that you stay as well. The rooms are spacious, beautifully decorated, and reasonably priced. There's also a full-service restaurant and bar.

Photo Tips

Photograph both the inside and outside of La Posada.

For photographs of your room, you'll need a tripod to steady your camera during a long exposure in the low-light situation. Sure, you could use a flash, but the harsh light from the flash will ruin the mood and romantic feeling of the setting.

Outdoors, take pictures of the detail on the fantastic ironwork found around the property. Try to use the gates to frame the building.

Be Here or Be Square

"Here It Is" Sign
Jack Rabbit Trading Post
3386 Route 66
Joseph City, AZ 86032

This old, grungy sign has a great marketing story behind it. To attract drivers to stop at the trading post, a series of bright yellow billboards featuring a mysterious rabbit were spaced along the route. As you got closer to the trading post, the rabbits got larger until you finally arrived at the "Here It Is" sign. This is a classic Route 66 attraction and worth the short detour on the drive between Holbrook and Winslow. There is a giant saddled fiberglass rabbit here, too, so you can get two cheesy photos in one stop.

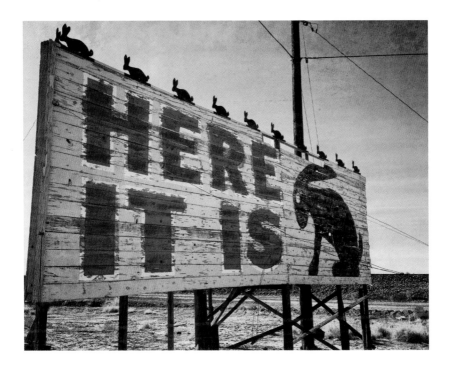

Photo Tip

Here our best photo tip for the sign: Just shoot it. To add a sense of scale to your photograph, include a person in the scene and photograph the scene from an angle. The sign looks the same from both sides, so it does not matter what time of day you pull off I-40 to take your shot.

Try adding a grunge effect to your photo of this grungy sign, as Susan did with her iPhone photo on the previous page.

Across the street from the sign is the Jack Rabbit Trading Post. They sell ice cold beer and hard liquor and lots of Native American and Old West souvenirs. There is also a restroom in case you need to make a stop before your next destination.

And for a fun photo memory, have your road trip buddy pose on the famous jack-o-lope.

A Cool Pit Stop

Geronimo's Trading Post
5372 Geronimo Road
Joseph City, AZ 86032
928-288-3241

The main reason to stop here, we feel, is to see examples of petrified wood—especially if you don't stop at the Petrified Forest, which we skipped.

In front of the trading post are large sections of trees that have been petrified. A sign says you can see them for free. You can also take photos for free. There are also several teepees that are also free to photograph.

We liked our close-up photographs of the sections of petrified wood. We especially liked the colors and patterns, which made for beautiful abstract shots.

Go inside the trading post and you will see most of the same stuff you see in all the trading posts along Historic Route 66. If you want a pair of moccasins, you can pick them up here.

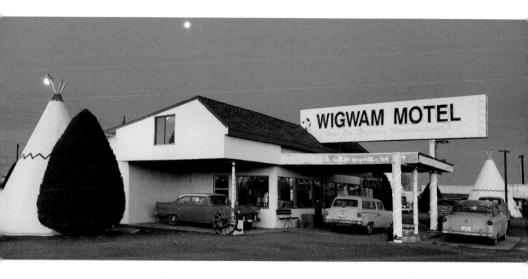

Cool at Sunrise and Sunset

HOLBROOK, ARIZONA

Wigwam Motel
811 W Hopi Drive
Holbrook, AZ 86025
928-241-8413
www.sleepinawigwam.com

For us, two locations on your road trip "say" Route 66: the Blue Swallow Motel is one, and the Wigwam Motel is the other. Both of these properties have been welcoming road trip guests for many years. They are unique. They are quirky. They are extremely photogenic.

Being at the Wigwam Motel is like being on a movie set, complete with more than a dozen wigwams, in which you can stay for about $80. The property is also sprinkled with vintage cars, some in good condition and some that have seen much better days, which can add great interest to your images.

Photo Tips

Our advice here is twofold. One, you snooze you lose. That is, the best time to photograph at the Wigwam Motel is around sunrise and sunset—when the light is beautiful and when there are fewer people walking around. The picture on page 159 was taken at sunset.

Try to compose your photograph in such a manner that you hide the guests' cars behind the vintage ones. Also compose for separation. Try to leave space between the elements in the scene for a cleaner, less-cluttered image.

When photographing into the sun at sunset, as we did here for our favorite photograph, you will need HDR to capture all the details in the highlighted and shadowy areas of the scene. Learn about HDR in the **Rick's Quick Photo Tips for Route 66** section on page 29.

If you shoot at sunrise (with the sun at your back), you will not need HDR because the contrast range of the scene is much lower.

Rick is known for his inside-to-outside HDR images. Ask the owner if you can get inside one of the cars for this type of photograph. Rick made this image with his Canon 8–15mm lens set at 15mm on his canon 5D Mark IV. It was created from a seven-exposure HDR sequence.

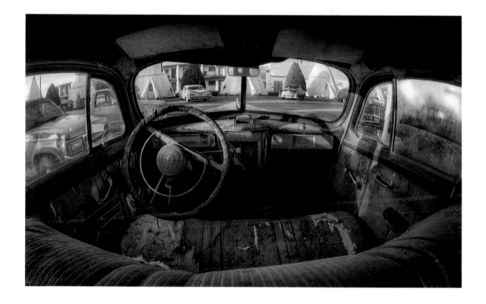

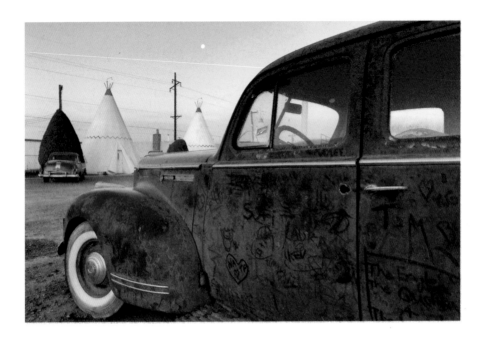

Try to photograph subjects from an angle to add a sense of depth to an image. Also, don't take all your photographs at eye level. That can get boring after a while.

Restaurant Recommendations

Turquoise Room & Martini Lounge at La Posada Hotel

303 E 2nd Street (Route 66)
Winslow, AZ 86047
928-289-2888
www.theturquoiseroom.net

If you are staying in Winslow, dine at the Turquoise Room & Martini Lounge at the La Posada Hotel. The dining room

has a ton of style and the menu features retro Fred Harvey specialties and Native American–inspired *nouvelle cuisine*. You'll want to make a reservation, as it can get booked up for dinner.

Two casual local restaurants are right across the street from one another in Holbrook. Both offer Southwest and American dishes with a helping of friendly service. We preferred the wonderful and friendly atmosphere at Romo's.

Romo's Restaurant
121 W Hopi Drive
Holbrook, AZ 86025
928-524-2153

Joe and Aggie's Café
120 W Hopi Drive
Holbrook, AZ 86025
928-524-6540

If you want a more familiar meal, there are several fast food places in town, including McDonalds and Denny's, just off I-40.

Next Stop: Williams, and then on to Grand Canyon. Drive time from Holbrook to Williams is under 2 hours.

WILLIAMS, ARIZONA, AND
GRAND CANYON
NATIONAL PARK

Most travelers who stop at Williams, Arizona, also stop at the Grand Canyon, and vice-versa. That's why we decided to put these two must-see and must-photograph destinations in one chapter.

Williams was built as a railroad town and the railroad is still the main attraction. You can take a historic train ride from the center of Williams to the south rim of the Grand Canyon. If you go by train, be sure to check out the vintage sightseeing cars, such as the one illustrated here.

Another option is to make the easy 1-hour drive on your own, as we did.

No matter how you approach it—by rail or road—Grand Canyon National Park is one of the most impressive natural wonders that you will ever see due to its sheer size, palette of golden colors, and interesting shadows.

You will also find a Route 66 vibe in the architecture in Grand Canyon Village, one of the main concession areas for visitors to the South Rim. Many of the historic buildings here were built to support the growing number of early rail and road trip visitors.

Let's begin our road trip to this area of Route 66 in Williams.

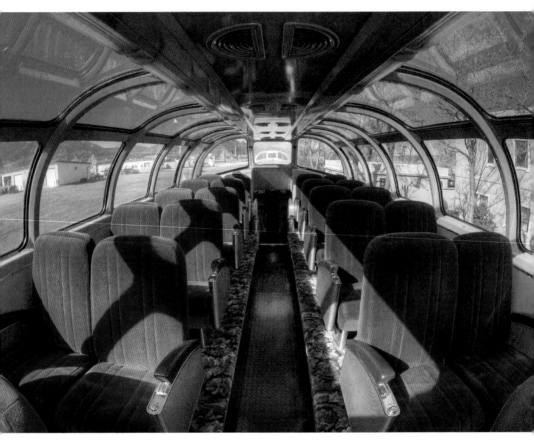

A side trip by train to the Grand Canyon is fun, especially if you ride in a sightseeing car

Gateway to the Grand Canyon

WILLIAMS, ARIZONA

Unlike many of the towns we visited on Route 66, Williams is a lively place with very few abandoned buildings. The railroad has kept this town "on the map." There is a busy main street filled with restaurants, shops, and tourist attractions. The road into Williams takes you through some lovely forest areas with the fragrance of pine trees—a refreshing contrast to seeing desert scrub.

Grand Canyon Railway Hotel

235 N Grand Canyon Boulevard
Williams, AZ 86046
928-635-4010
www.thetrain.com

Make your way to the center of town and find the Grand Canyon Railway Hotel, where we stayed, to experience the railroad theme. It is a nice, convenient place to stay since it is within walking distance of the train depot and main street activities. The historic train depot located right behind the hotel was built more than 100 years ago and continues to shuttle riders to and from the Grand Canyon.

Trains depart the depot daily at 9:30 a.m. and return at 5:45 p.m. You can take photos from the platform even if you are not taking the train. During peak season, additional trains are added. In addition, there is a permanent locomotive and a few other railway cars on-site to photograph close up for some really cool details.

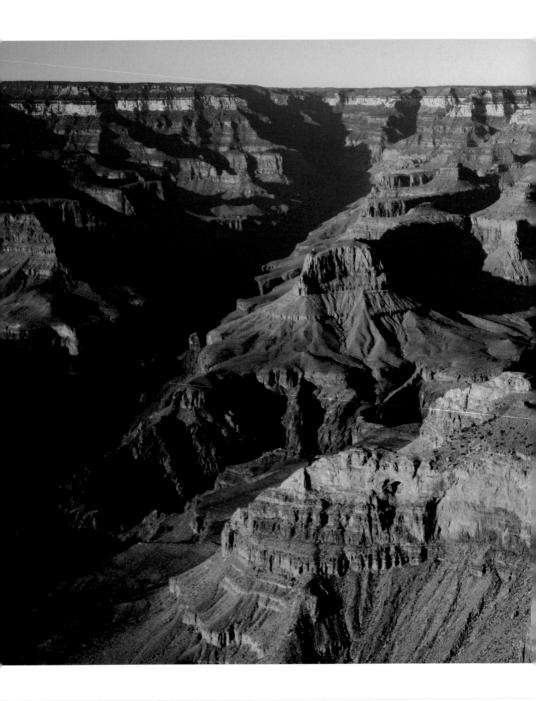

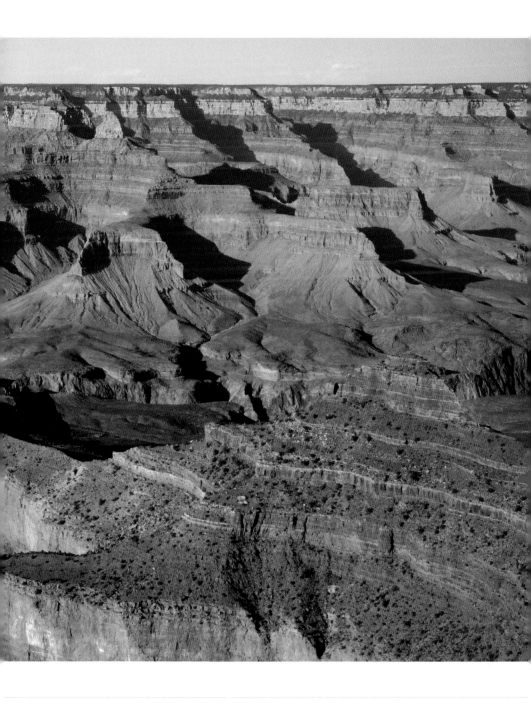

Photo Tips

Williams is a train photographer's paradise, as illustrated by this iPhone photograph by Susan. With some careful composition, combined with some skillful photo processing (an app called Snapseed here), you can make some wonderful images with your smartphone camera.

In all your photographing adventures, be mindful of the background. Notice how Susan carefully composed her shots so no distracting background elements interfered with the main element of her photographs, the locomotive.

The opening image for this chapter on page 166, an HDR image by Rick with his Canon 5D Mark IV and 15mm lens, shows one of the sightseeing cars on the train that goes to the Grand Canyon. If you don't take the train but still want to get an image like this, ask the conductors in

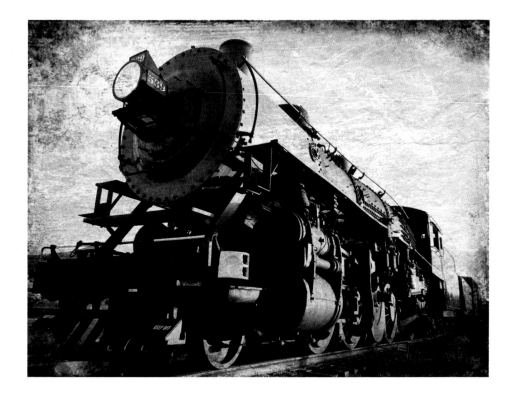

the train station if you can hop on the train while it is in the station. Rick did this on both our trips, and the conductors readily said, "Okay . . . if you work fast."

Working fast means setting up your camera and tripod before you get on the train, and then getting on the train and shooting for only a few minutes. In this high-contrast lighting situation, you will need to take several exposures—as Rick did for the opening image in **Rick's Quick Photo Tips for Route 66** on page 29—for your HDR image.

For quicker, fun shots, you can set your camera on one of the automatic modes or simply use your smartphone—which is what Susan did for her locomotive image. She used Snapseed to process her image for a creative and artistic effect.

Sure, photograph the massive locomotives, but don't forget to focus on the details, too. That's what Susan did for this picture, also processed in Snapseed, of the wheel of the same train in the previous photograph.

Restaurant Recommendations

Cruiser's Route 66 Café
233 Route 66
Williams, AZ 86046
928-635-2445
www.cruisers66.com

Many restaurants and shops welcome visitors in Williams. Cruiser's Route 66 Café offers a combination of good food and good subjects to photograph. It is decorated in a retro diner style, heavy on the classic car motif. Outdoor seating and live music make it a hub of activity. Lots of Route 66 memorabilia is on display here and for sale in the gift shop. At night the neon lights come on and warm up the whole block with a vintage feel.

Cruiser's offers typical pub food, including burgers and ribs. We had the pulled-pork sliders and fries that hit the spot after a day of photographing.

Ask to see the beer menu at Cruiser's Café. Many local brews are available here to complement your burger or barbeque dinner. And

speaking of beer, Williams is the home of the Grand Canyon Brewing Company, which offers a nice selection of ales, pilsners, and IPAs. Our favorite was the Black Iron IPA.

Even if you don't need it, you might want to visit the men's room at Cruiser's. It's one of the coolest men's room Rick has even seen. This panorama shows all the Route 66 memorabilia that is crammed into this one-of-a-kind WC.

Pine Country Restaurant

107 N Grand Canyon Boulevard
Williams, AZ 86046
928-635-9718
www.pinecountryrestaurant.com

We had lunch and dinner at the Pine Country Restaurant on our most recent Route 66 trip, and we had breakfast there on our previous visit. So it's safe to say we love this place! The restaurant is open from 7 a.m. to 9 p.m., so you can

get classic breakfast, lunch, and dinner items as fits your schedule. The restaurant prides itself on its pies, which are homemade and come in a variety of flavors, from classic Apple and Boston Cream, to a few more interesting flavors like Strawberry Peanut Butter and Grasshopper Mint.

Don't Miss the Grand View

SOUTH RIM, GRAND CANYON NATIONAL PARK

You will find endless good photo vantage points, some marked, some unmarked, on the South Rim of the Grand Canyon. It's a wonderful walk, culminating in the unforgettable experience of looking down into the magnificent canyon.

The Rim Trail can be accessed from two of the main tourist centers: the Visitor Center and Grand Canyon Village.

If you start at the Visitor Center, follow the crowd toward Mather Point, stopping to take photos with a good viewpoint anywhere along the way. If you begin your walk at Grand Canyon Village, you can capture dramatic canyon views and historic buildings as this section of trail leads to El Tovar Hotel and Hopi House.

Closer to Bright Angel Lodge, you can take a photograph of the canyon that includes Lookout Studio, a lovely stone structure designed by the same architect, Mary Jane Colter, who designed La Posada Hotel in Winslow, Arizona. If you are lucky, you might see the daily mule train heading down Bright Angel Trail.

There is an entry fee at Grand Canyon, but you can use your National Parks Pass if you have one and remember to bring it. Either way, it is so worth it!

Stop and Go on Desert View Drive

For the early morning light, we recommend taking the road less traveled along Desert View Drive. This is a long stretch of road designed with many pullouts offering spectacular viewpoints including Yaki Point, Grandview, and Navajo Point. You can stop and go at your own pace, which is really nice for photography.

Photo Tips

The Grand Canyon, with its sweeping vistas, offers endless landscape photo opportunities, as well as an opportunity to take some fun shots of your family and friends on the hiking trails and on muleback.

There are two major factors to consider when taking landscape photographs in this wonderful national park. First, be aware of the horizon line, which is virtually flat. Second, watch for shadows, which can add a sense of depth to a scene.

If there are no clouds in the sky, compose your scene so the horizon line is at the top of the frame. If there are clouds, compose the scene so the horizon line is not exactly in the center of the frame. Dead center is deadly when it comes to composition.

You will see the most dramatic shadows in the early morning and late afternoon. If you photograph around sunrise and sunset, the shadows may comprise too much of your frame.

Due to the contrast range between the shadows and highlights, you may want to use HDR.

The main idea in composition is to "cut the clutter." At the Grand Canyon, try to "cut the clutter" and select an interesting section of the landscape.

Another idea is to use a foreground element to add a sense of "being there" to the scene.

For your people pictures, be sure to include the background, which tells the story of you being at the Grand Canyon.

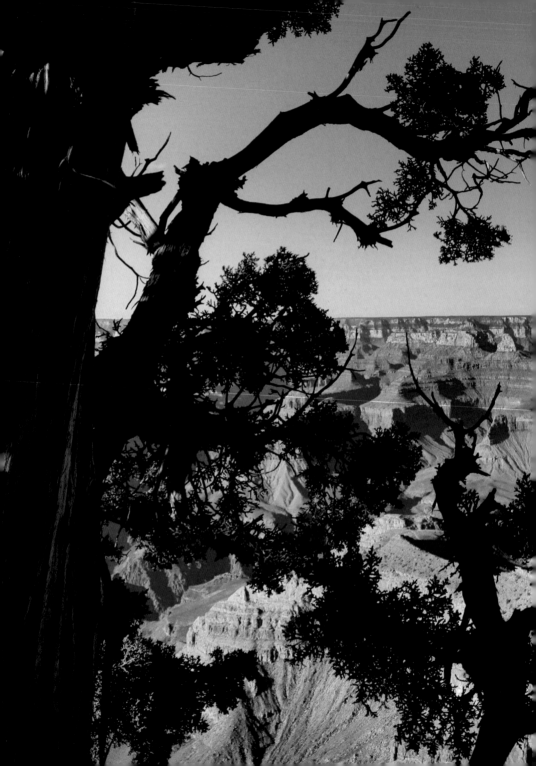

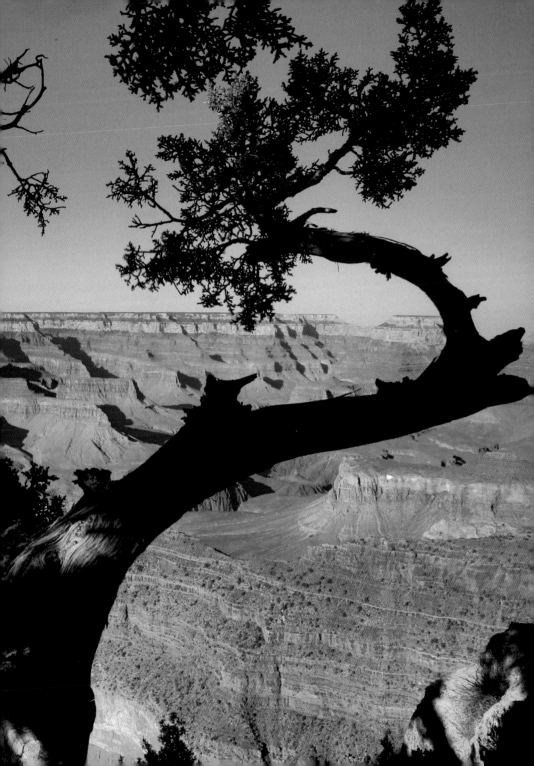

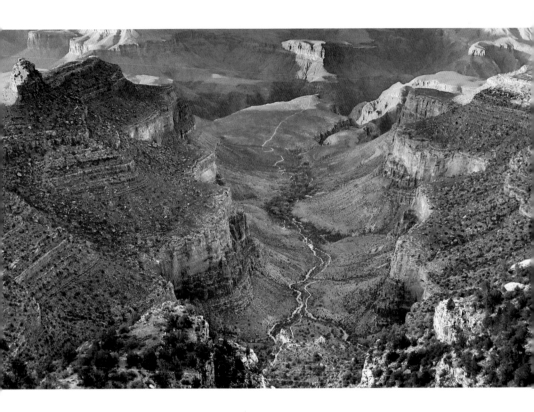

If you take the mule ride down to Plateau Point, our advice is to take only one camera with perhaps a 24–105mm lens. Keep it on an over-the-shoulder strap for easy access.

For another sense of "being there" photograph, include part of the mule's body or head in the frame. Use a small aperture to get the entire scene in focus.

As you can see in this photograph, the sky can cloud up and it could rain. Be prepared with a plastic camera cover to keep you camera safe and dry. The riders give you a yellow raincoat to keep you dry.

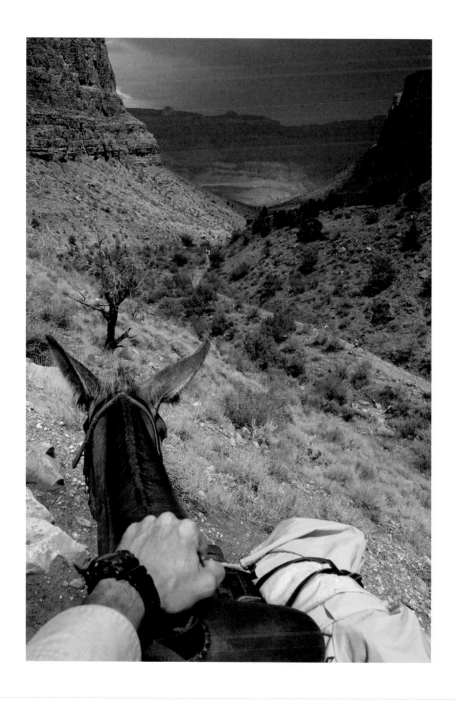

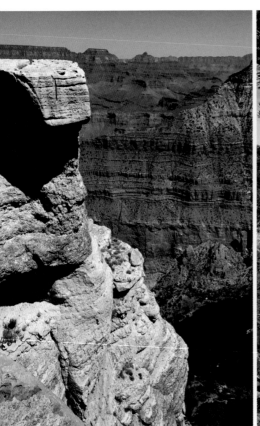
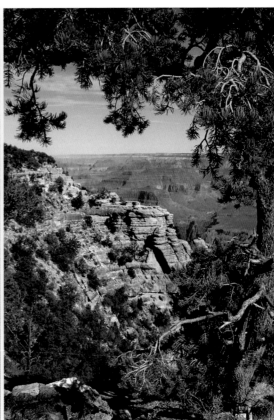

This might be the most basic photo tip in this book, but it's a good one: Take vertical shots, too. Some novice photographers overlook taking vertical pictures when it comes to photographing landscapes. These pictures can have impact, too.

Sure, you can use a high-end digital SLR, as Rick did, to capture the grandeur of the Grand Canyon, but look how Susan used her iPhone to make this dramatic black-and-white image.

Susan also took this selfie-shadow image with her iPhone. One of her photo tips is to take fun shots in addition to the postcard and art shots.

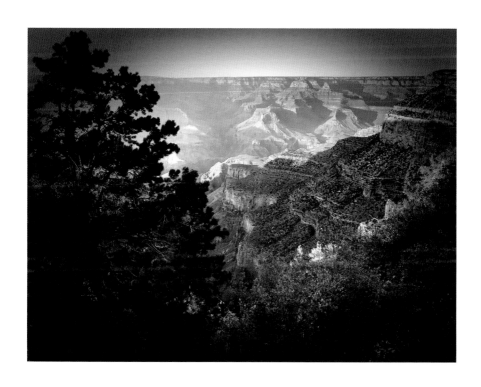

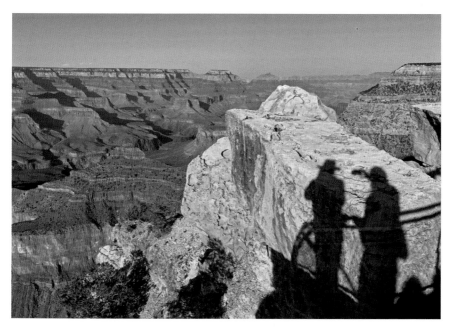

Lodging

The Grand Canyon is one of the top travel and photographic destinations in America. With millions of visitors every year, it is also one of the busiest.

Unlike the smaller stops on a Route 66 road trip, where you can find a place to stay or a place to eat with ease, your Grand Canyon stop requires planning. You'll want to have a hotel booked well in advance, maybe even a year ahead of your visit.

There are some wonderful lodges inside the park that are perched right on the rim of the canyon, including the historic Bright Angel Lodge and the luxury historic hotel El Tovar. It is an amazing experience to stay at one of these properties as you have the canyon as your constant companion.

But don't worry if you miss out on an in-park room. There are many hotels and motels located just outside the park entrance.

Best Western Premier—Grand Canyon Squire Inn
74 Highway 64
Tusayan, AZ 86023
928-638-2681
www.grandcanyonsquire.com

Tusayan, Arizona, is the home of many well-known chain hotels. These properties, including the Best Western Premier/Grand Canyon Squire Inn where we stayed, feature newer and more comfortable rooms—a welcome trade-off for being off-site. Another nice perk is free shuttle bus service from Tusayan to the most popular stops on the rim. This is a big advantage when parking lots are full during the popular tourist season. The Best Western in town offers good rooms and services, including a large pool area.

Restaurant Recommendations

There is cafeteria-style food offered at concession stands inside the park and fast food stops outside the park. For a sit-down dinner with a wonderful view, make a reservation at the Arizona Room Restaurant in Bright Angel Lodge. While the food is not inspiring, the view from your table is—you'll be sitting just yards away from the south rim.

If you want a more upscale dining experience, make a reservation at the dining room at the El Tovar hotel. Even if you don't eat here, it is worth a visit just to see the lobby and dining room. El Tovar reflects the golden age of the National Parks, when early stewards, including Teddy Roosevelt, stayed here.

Arizona Room Restaurant (at Bright Angel Lodge)
9 North Village Loop Drive
Grand Canyon, AZ 86023
928-638-2631
www.grandcanyonlodges.com/lodging/bright-angel

El Tovar Dining Room (at El Tovar)
1 El Tovar Road
Grand Canyon, AZ 86023
928-638-2631
www.grandcanyonlodges.com/dining/el-tovar-dining-room-and-lounge

Next Stop: We hope to see the "Angel of Route 66" in Seligman, Arizona. Drive time from Grand Canyon to Seligman is 1 hour and 45 minutes.

SELIGMAN, HACKBERRY, KINGMAN, AND CHLORIDE, ARIZONA

The longest remaining stretch of Route 66, a 158-mile run, allows enthusiasts to drive from just outside Ash Fork, Arizona, all the way to California. If you want to get off the interstate and really feel the road, this is the place to do it.

Whether you take the fast road or the slow road, there are lots of interesting stops along the way, including the towns of Seligman, Hackberry, Kingman, and Chloride. These locations offer everything from a charming, revitalized main street to a ghost town in the making.

Because these locations are relatively close to each other, we decided to include them all in one chapter.

Slow down in Seligman—and enjoy all the sights!

The Angel of Route 66

SELIGMAN, ARIZONA

The first stop is one of our favorites. Why? Seligman is the center of the "rebirth" of Route 66 and the home of its guiding light, Angel Delgadillio. The town is a required stop on any Route 66 road trip.

Angel & Vilma Delgadillo's Original Route 66 Gift Shop

22265 Route 66
Seligman, AZ 86337
928-422-3352
www.route66giftshop.com/the-angel-of-route-66

The story of Angel's vision and commitment is an inspiration. He and his brother were small business owners when the construction of I-40 cut off the flow of customers. So he organized a group to make old Route 66 a "historic" highway.

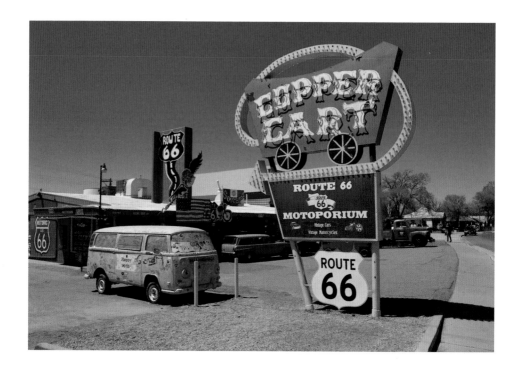

Angel loves meeting tourists—and especially photographers. When we arrived at his shop, his daughter told us that he was at home relaxing. I said that I was sorry that I missed him. She saw the disappointment in my face and said, "Wait, I'll give him a call. He can be here in 10 minutes." Ten minutes later, Angel showed up on his bicycle. At 90 years old, he rode his bike to see me! How cool is that?

The "historic" highway designation turned things around along Route 66, and people starting coming back, breathing new life into Seligman's Main Street. Angel and his family love to share their story. You can find them at their Route 66 Gift Shop where, if you are lucky, Angel will be in the house to pose for photos.

Seligman has a fun-loving vibe. Lots of people stop here, including whole tour buses of visitors. It is a wonderful place to find a cup of coffee and then stroll the colorful few blocks in the tourist zone. Lots of cheerful signs will lift your spirits and make great subjects for photographs.

Photo Tips

Have your picture taken with Angel. If it's sunny outside, shoot in the shade where low contrast makes getting an even exposure easy. As with all people pictures, see eye-to-eye and shoot eye-to-eye. When the camera is at eye level, the person looking at the subject can easily identify with the subject.

You could take a head shot of Angel, but that would not tell the story of his historic barbershop. Our advice is to take an environment portrait—that is, a portrait that includes the person and the surroundings. A zoom lens in the 24–105mm range, set at around 35mm, is a good choice for environmental portraits.

Indoors, you will need to boost your ISO for a steady hand-held shot. Outdoors, try to compose your scene so Angel is in the shade, where the contrast is low and even, and produces flattering lighting.

Photograph the old cars that you'll find on the street. Use one car

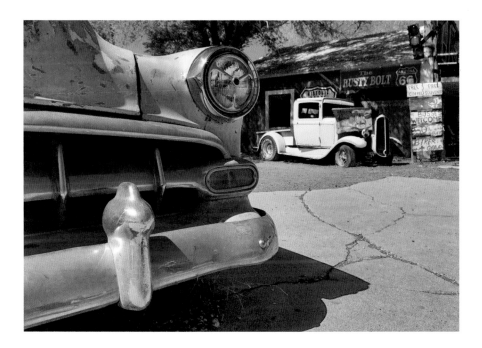

as a foreground element and another as a background element. And for a real creative shot, get down low and position yourself close to the car in the foreground. This composition makes for a "sense of place" photograph. Use a wide-angle lens and choose a small aperture to get the scene in focus

Historic Seligman Sundries

22405 Route 66
Seligman, AZ 86337
928-600-0123
www.seligmansundries.com

Need a great cup of coffee and a snack? Don's miss Historic Seligman Sundries, just down the street from Angel's barbershop. And don't be shy about ordering a cappuccino. It was the best we had on the trip—and one of the best we've had in our travels. The biscotti were very good, too.

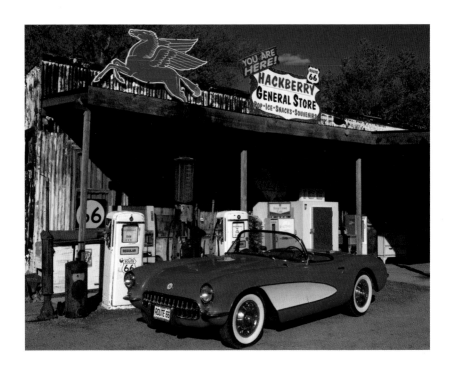

The Coolest General Store on Route 66

HACKBERRY, ARIZONA

Hackberry General Store
11255 Route 66
Hackberry, AZ 86411
928-769-2605
www.hackberrygeneralstore.com

Hackberry is another well-visited Route 66 destination. The main attraction—actually the only attraction—is the Hackberry General Store, another Route 66 landmark.

The store's proprietor, John Pritchard, has created an iconic stop filled with Route 66 artwork and merchandise. Look for a gorgeous red

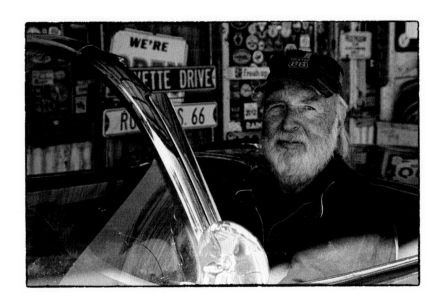

1957 Corvette convertible out front; when you see it, you'll know you have arrived.

Photo Tips

Try to get there late in the afternoon when the sun illuminates the front of the general store. If the red Corvette is not parked in a good photo position, ask John if he will reposition it, which is what he did for us.

John is a super friendly guy. Ask him if you can take his photo, too. For a retro Route 66 shot, make a black-and-white or sepia tone image.

If you could take only one photograph, we suggest framing your shot with the red Corvette near one end of the frame and the Model A Ford at the other—with the store as your background. Use a wide-angle lens and small aperture to get the entire scene in focus. Your picture may be rather busy, but it tells the story of the location.

Use the "rule of thirds" composition technique for this together shot. Imagine a tic-tac-toe grid over the frame and place the car and Pegasus sign where the lines intersect.

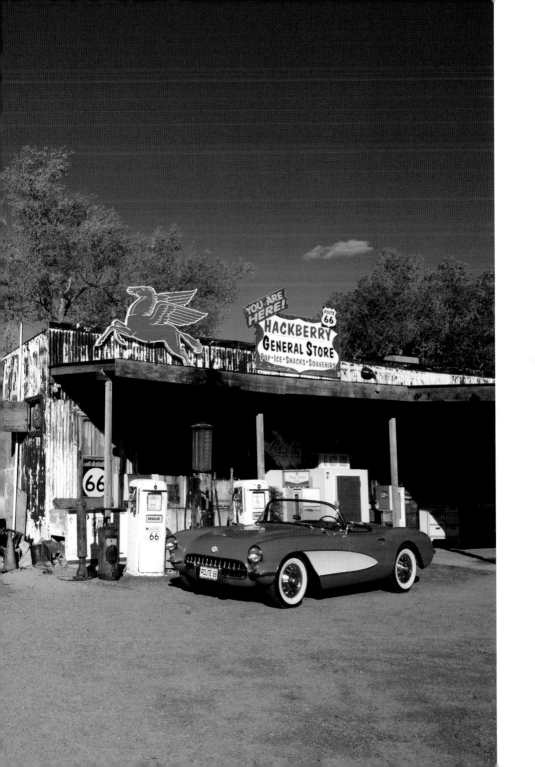

A Taste of Route 66

KINGMAN, AZ

Mr. D'z Route 66 Diner
105 E Andy Devine Avenue
Kingman, AZ 86401
928-718-0066
www.mrdzrt66diner.com

One of the main attractions here is the wonderful Mr. D'z Route 66 Diner. This retro diner is busy and the food is good, too. Rick loved his club sandwich, and Susan enjoyed her salad. If you go, don't miss the house special drink: homemade root beer.

Photo Tips
The Mr. D'z Diner sign is one of the trademarks of Route 66. Tilt your camera to the left or right for an effect that's called disequilibrium. This off-balance composition technique adds a cool and creative touch to the photograph.

When you go inside the diner, have your camera ready to photograph the retro décor. If you are patient, you can get your traveling buddy in the frame along with Elvis and Marilyn.

Don't use a speedlite, as it will ruin the mood of the diner. Rather, boost your ISO for a natural-light shot.

Powerhouse Visitor Center and Route 66 Museum

120 W Andy Devine Avenue (Route 66)
Kingman, AZ 86401
928-753-9889
https://kingmancircle.com/gokingman/

Just across the street from the diner is the Powerhouse Visitor Center and Route 66 Museum. The rest of the historic road in town is lined with a mix of retro and deteriorating motels, as well as newer looking buildings. For the Route 66 feel, stick to the diner and museum on this stop.

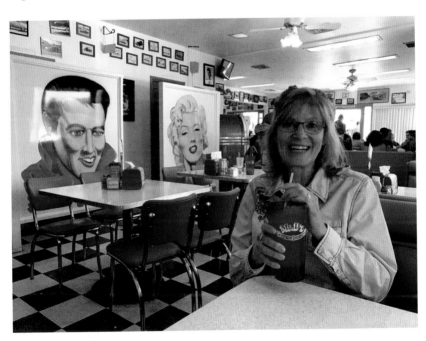

And Now for Something Completely Different

CHLORIDE, ARIZONA

Chloride is a trip you need to make. You'll be off Route 66, but you'll still be going back in time. Look for the sign to Chloride as you travel north out of Kingman on Route 93. This former mining town is now a quirky stop for road trippers. It's not a ghost town, but it could be used as a ghost town movie set.

The small population of Chloride, around 300, is keeping the place alive. The town puts on a Wild West-themed show Saturdays at noon. Grab some food and refreshments while you are there at either The Prospector or Yesterday's, which hosts a karaoke session on Saturdays.

Photo Tips

Chloride, like Hackberry, offers one "trademark" photograph that surely is worth taking. It's at the abandoned gas station that you see on your left on the way into town.

Compose your photograph with the railroad tracks that run past the gas station. Shoot from an angle (as opposed to photographing the building head on), use a wide-angle lens, and frame you shot so the tracks run though the bottom of your image.

If you want even light, the late afternoon is the best time to photograph this scene. We were there mid-afternoon, when strong shadows created strong contrast. Rick opened up the shadows and toned down

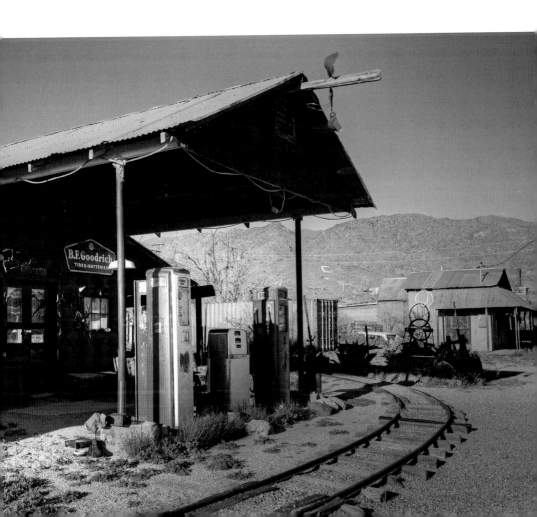

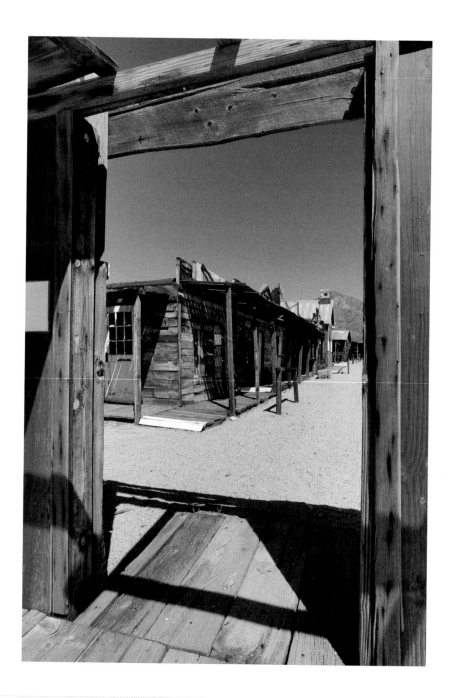

the highlights in Lightroom. Had the contrast range been stronger, HDR would have been needed.

The re-creation of an old Western town is another photo opportunity. If you are there on the weekends, so are the cowboy actors.

We were in Chloride on a weekday, so we missed the show. Still, we had fun photographing the town. To add a sense of depth to your photographs, use a foreground element to frame your shot. As with the gas station shot, shoot at an angle, use a wide-angle lens, and choose a small aperture.

Don't forget the fun shots. That's Rick playing a piano in a bar in the old Western town, photographed by Susan with her iPhone. We would have made a movie, but the piano sounded like it had not been tuned since the 1800s. Photograph at an angle to add a sense of depth to your photograph.

You will also find some nice close-up photo opportunities in the bar, including colorful bottles. Because the bottles are highly reflective, watch for overexposed areas of your image. If you have an SLR or mirrorless camera, check your highlight alert. If you have a smartphone, set the exposure on the brightest part of the scene.

Restaurant Recommendations

The Prospector (formerly Digger Dave's Bar and Grill)
4962 W Tennessee Avenue
Chloride, AZ 86431
928-565-3283

Yesterday's Restaurant
9827 N 2nd Street
Chloride, AZ 86431
928-565-4251

Next and Final Stop: Nelson, Nevada. Drive time from Chloride to Nelson around 1 hour and 30 minutes.

TECHATTICUP,
NEVADA

Photographers love a side trip off of their Route 66 adventure. For us, the detours up to Santa Fe in New Mexico and into the Grand Canyon in Arizona are photography pilgrimages with rich connections to the golden age of road travel. Now, as our itinerary makes its final turn off the Mother Road in Nevada, we have one more stop filled with vintage charm and photographic treasures. The Techatticup Mine, a precious metals extraction operation that closed in the mid-1940s, is open to photographers and adventurers yearning to take a step back in time.

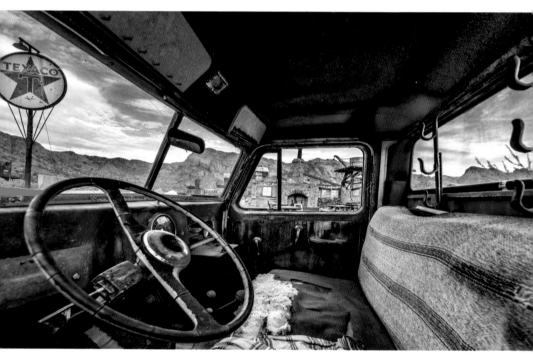

You can't miss the Techatticup Mine; it is marked by a vintage Texaco sign

A Gold Mine for Photographs

Techatticup Mine
16880 State Highway 165
Nelson, NV 89046
www.eldoradocanyonminetours.com/index.html

If you are ending your official Route 66 itinerary in Chloride, Arizona, as we did, you'll be just a 90-minute drive from Las Vegas, Nevada—the city from which we flew home.

You will find many photo opportunities between Chloride and Las Vegas, including the Grand Canyon Skywalk, Hoover Dam, and the historic Techatticup Mine. With many old cards and barns, Techatticup is a worthwhile extension on a Route 66 road trip—although it's not on Route 66.

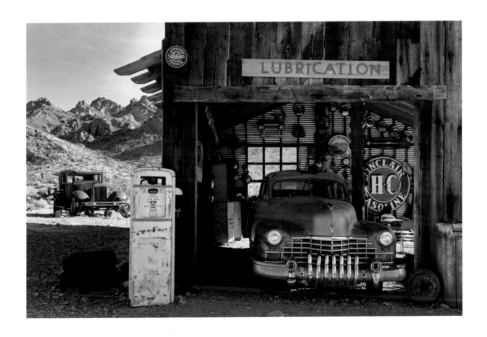

Where the heck is Techatticup? Well, put "Nelson, Nevada" in your GPS; once you get to Nelson, keep on driving for a few minutes and you will find it! When you see the Texaco sign, you will know that you have arrived.

Techatticup may be an abandoned gold mine, but it is an active gold mine of photo opportunities for photographers. Dozens of vintage cars, two vintage airplanes, and a few old barns and building are perfect for one-shot and HDR photography, wide-angle and close-up photography.

This is a private ghost town. You need to check in at the office when you arrive. Check the sign outside the main building for the rules and guidelines.

You will not find a McDonalds, or any other restaurant, in Techatticup. Plan on bringing your own water and a snack. And don't forget your sunscreen and a hat.

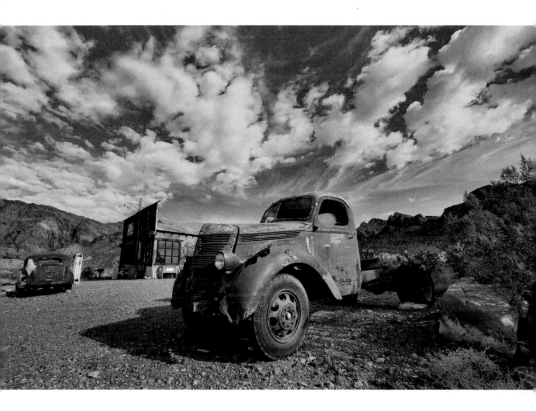

Photo Tips

Like many outdoor locations, Techatticup is best to photograph early in the morning or late in the afternoon. You can also take pictures at night, perhaps for some lighting painting, but you need special permission from the owners.

Bring your wide-angle zoom, tripod and be ready for HDR photography, covered in **Rick's Quick Photo Tips for Route 66** section on page 29.

Technically, the most important aspect of photographing in Techatticup is to watch your aperture, because depth-of-field is important and nothing is moving. For most of your photographs, we think you will want to shoot at a smaller aperture (f/8, 11, 16, or 22) for good depth-of-field.

Some of Rick's favorite inside-to-outside HDR images were taken

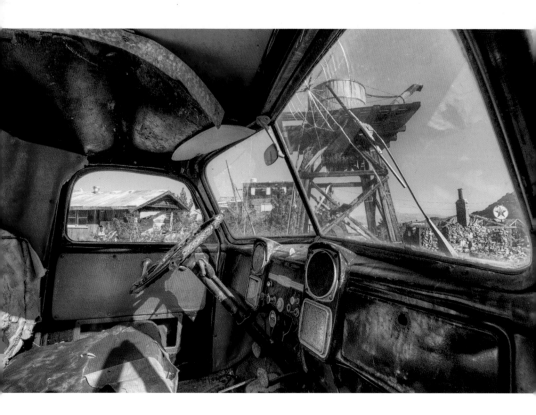

in Tachitticup. Briefly, the key to a good HDR is to capture the entire dynamic range of the image in a series of images. Done successfully, you will be able to see detail inside and outside in the same scene—detail that you may not even see with your eyes.

When you find a subject you want to photograph, tell the story of that subject.

Take vertical photographs. If the sky is nice, include it in the frame.

Take a horizontal photograph. Watch the background to see if it makes or breaks the photograph.

Take close-up shots, too. You don't need a macro lens for your

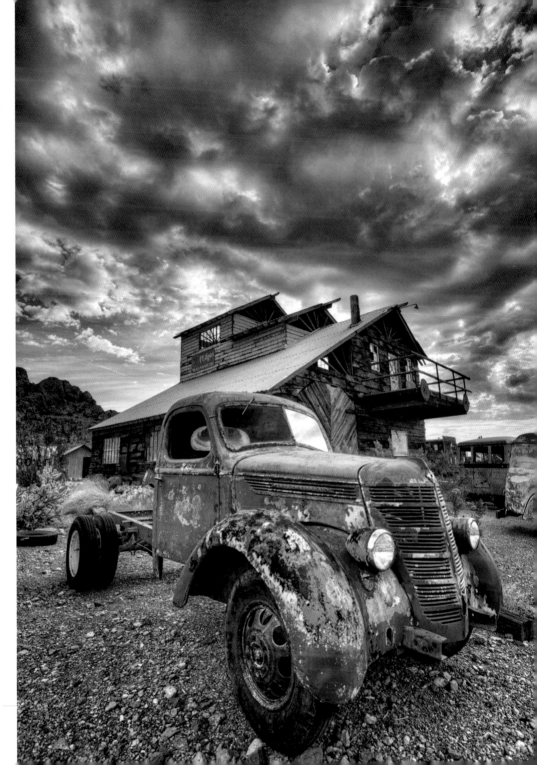

close-up shots. Simply set your zoom lens on the close-up setting, or shoot a wider area and crop the image for your close-up.

Don't miss the vintage airplane that is on the opposite side of the road from the main building. Photograph the plane from difference angles. Try framing your photographs so that the hill behind the plane adds a nice background to your image. If there are clouds in the sky, use a neutral density filter and make a long exposure—or simulate a long exposure in Photoshop using the Blur filter (Filter > Radial Blur > Zoom)—as Rick did for this image.

Be very careful around the airplanes, and don't climb on them. Climbing is not allowed, as it could damage the displays.

Also be careful about overexposed highlights when photographing the planes that have reflective parts. Make sure your high-

light alert is activated. If you get the "blinkies," reduce your exposure until they disappear.

A final note: Be very careful when walking around the old cars and barns. There are lots of cacti around—cacti that have needles that seem to jump out of the plants and into your legs. That's a big ouch! Wearing long pants and hiking boots may save you from some pain.

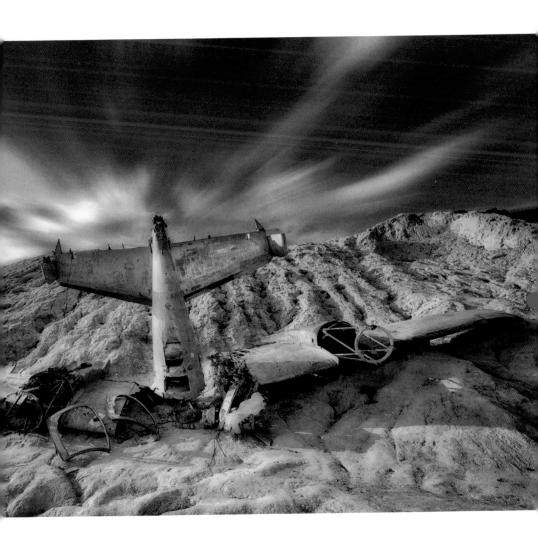

APPENDIX: DRIVER'S LOG

2017 Route 66 Road Trip

We had a ton of fun on our road trip, but it was also a lot of work—driving from location to location, making pictures, downloading files, and processing images in each location, grabbing a bite to eat, and staying in a different hotel every night.

Here is our itinerary for our 9-day, one-way trip from Albuquerque, New Mexico to Las Vegas, Nevada.

Drive safely.

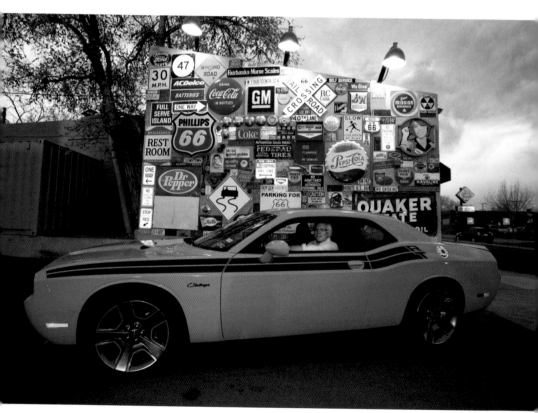

April 8
ALBUQUERQUE, NEW MEXICO
66 Diner
1405 Central Avenue NE
Albuquerque, NM 87106
www.66diner.com

Absolutely Neon
3903 Central Avenue NE
Albuquerque, NM 87108
www.absolutelyneon.com

Enchanted Trails RV Park and Trading Post
14305 Central Avenue NW
Albuquerque, NM 87121
www.enchantedtrails.com

April 9
ALBUQUERQUE, NEW MEXICO
Hotel Andaluz
125 2nd Street NW
Albuquerque, NM 87102
www.hotelandaluz.com

San Felipe de Neri Church
2005 North Plaza NW
Albuquerque, NM 87104
http://sanfelipedeneri.org

Garcia's Kitchen
1736 Central Avenue SW
Albuquerque, NM 87104
http://garciaskitchen.com

SANTA ROSA, NEW MEXICO
Route 66 Auto Museum
2866 Will Rogers Drive (Route 66)
Santa Rosa, NM 88435

TUCUMCARI, NEW MEXICO
Trading Post on Route 66
1900 W Tucumcari Boulevard
(Route 66)
Tucumcari, NM 88401

Blue Swallow Motel
815 E Route 66
Tucumcari, NM 88401
www.blueswallowmotel.com

K-Bob's Steakhouse
200 E Estrella Avenue
Tucumcari, NM 88401
www.k-bobs.com/location/
new-mexico

April 10
TUCUMCARI, NEW MEXICO
Kix of 66
1102 E Route 66
Tucumcari, NM 88401
www.kixon66.com

Street Shooting on Route 66

SANTA FE, NEW MEXICO
The Pantry
1820 Cerrillos Road
Santa Fe, NM 87505
www.pantrysantafe.com

El Rey Inn
1862 Cerrillos Road
Santa Fe, NM 87505
www.elreyinnsantafe.com

Kaska-Katuwe Tent Rocks National Monument
Jemez Springs
Cochiti Pueblo, NM 87052
https://en.wikipedia.org/wiki/
www.blm.gov/nlcs_web/sites/nm/
st/en/prog/NLCS/KKTR_NM.html

Maria's New Mexican Kitchen
555 West Cordova Road
Santa Fe, NM 87505
http://marias-santafe.com

April 11
SANTA FE, NEW MEXICO
Loretto Chapel
207 Old Santa Fe Trail
Santa Fe, NM 87501
www.lorettochapel.com

San Migule Chapel
401 Old Santa Fe Trail
Santa Fe, NM 87501
www.sanmiguelchapel.org

Cathedral Basilica of St. Francis of Assisi
231 Cathedral Place
Santa Fe, NM 87501
http://cbsfa.org

GALLUP, NEW MEXICO
Richardson Trading Company
222 E Route 66
Gallup, NM 87301
www.richardsontrading.com

Train Shoot on Route 66

El Rancho Hotel
1000 E Route 66
Gallup, NM 87301
www.route66hotels.org

April 12
GALLUP, NEW MEXICO
Gallup Coffee Company
203 W Coal Avenue
Gallup, NM 87301

Red Rock Park
825 Outlaw Road
Church Rock, NM 87311
www.gallupnm.gov/207/
Red-Rock-Park-and-Museum

WINSLOW–HOLBROOK, ARIZONA
La Posada Hotel & Gardens
303 E 2nd Street (Route 66)
Winslow, AZ 86047
www.laposada.org

"Here It Is" Sign
Jack Rabbit Trading Post
3386 Route 66
Joseph City, AZ 86032

Geronimo's Trading Post
5372 Geronimo Road
Joseph City, AZ 86032

April 13
HOLBROOK, ARIZONA
Wigwam Motel
811 W Hopi Drive
Holbrook, AZ 86025
www.sleepinawigwam.com

Romo's Restaurant
121 W Hopi Drive
Holbrook, AZ 86025

Joe & Auggie's Café
120 W Hopi Drive
Holbrook, AZ 86025

WILLIAMS, ARIZONA
Pine Country Restaurant
107 N Grand Canyon Boulevard
Williams, AZ 86046
www.pinecountryrestaurant.com

Cruiser's Route 66 Café
233 Route 66
Williams, AZ 86046
www.cruisers66.com

Grand Canyon Railway Motel
235 N Grand Canyon Boulevard
Williams, AZ 86046
www.thetrain.com

April 14
WILLIAMS, ARIZONA

Street/Train Photography in Williams

GRAND CANYON, SOUTH RIM

Landscape Photography in National Park

Best Western Premier—Grand Canyon Squire Inn
74 Highway 64
Tusayan, AZ 86023
www.grandcanyonsquire.com

Arizona Room Restaurant (at Bright Angel Lodge)
9 North Village Loop Drive
Grand Canyon, AZ 86023
www.grandcanyonlodges.com/
lodging/bright-angel

April 15
GRAND CANYON, SOUTH RIM

Landscape Photography in National Park

SELIGMAN, ARIZONA
Angel & Vilma Delgadillo's Original Route 66 Gift Shop
22265 Route 66
Seligman, AZ 86337
www.route66giftshop.com/
the-angel-of-route-66/

Historic Seligman Sundries

22405 Route 66

Seligman, AZ 86337

http://www.seligmansundries.com

HACKBERRY, ARIZONA (ON PREVIOUS TRIP)

Hackberry General Store

11255 Route 66

Hackberry, AZ 86411

www.hackberrygeneralstore.com

KINGMAN, ARIZONA

Mr. D'z Route 66 Diner

105 E Andy Devine Avenue (Route 66)

Kingman, AZ 86401

www.mrdzrt66diner.com

Kingman Powerhouse Visitors Center and Route 66 Museum

120 W Andy Devine Avenue (Route 66)

Kingman, AZ 86401

https://kingmancircle.com/gokingman/

CHLORIDE, ARIZONA

The Prospector (formerly Digger Dave's Bar and Grill)

4962 W Tennessee Avenue

Chloride, AZ 86431

Yesterday's Restaurant

9827 N 2nd Street

Chloride, AZ 86431

April 16
LAS VEGAS, NEVADA

Techatticup, NV

16880 State Highway 165

Nelson, NV 89046

www.eldoradocanyonminetours.com/index.html

We can't leave this chapter without a photo tip! Take a "before-trip" and "after-trip" picture of your car's odometer. Those photos will bring back fun memory of your miles—1,656 miles on our trip!

INDEX

To Iain, Thanks!

the
Everyday

Adam Cadwell

THOUGHT BUBBLE 2014

ISBN: 978-0-9574318-4-3

First printing, November 2012.

Published by Great Beast Comics, Manchester, UK.
Publishers: Adam Cadwell and Marc Ellerby.
To view our catalogue please visit
www.greatbeastcomics.com

Printed in Lithuania.

Foreword
by Matthew Sheret

You're about to read the most accurate handbook to life in the early part of the 21st century I've yet encountered.

It's a life of wiki-searches, soundtracks, band t-shirts and walking. Loads of walking. Adam Cadwell, The Everyday's artist and star, guides you through it all effortlessly, taking you from the streets of Manchester to the depths of the London Underground, stopping in New York, Stockholm, Toronto and Glastonbury Tor along the way.

Collecting some 200 strips this book shows Adam growing into one of Britain's strongest storytellers. In three panels he'll take you from laughter to tears, sparking moments of recognition at every turn. Online these comics united a community of creators in praise, all of us seeing little slices of our own life reflected in the moments Adam teased into such lovely stories.

Adam's two-tone palate gave The Everyday an identity of its own. His clean lines flowed onscreen, and made his comic pop at readers used to creators desperately using every colour a browser could handle.

As a regular reader online, the thing I remember most strongly about The Everyday was the tremendous sense of fun that bled from each panel and through the screen. This collection loses none of that. Yes, from time to time you'll get a tear in your eye, but these comics have such a spring to them that it's going to be difficult to stop smiling when you close the book.

Adam's Vimto-tinted perspective on life remains a delight. At its best The Everyday makes me treasure the commonplace moments in life, and that's a wonderful gift.

Matthew Sheret,
in the sun on a gravelly roof in Shoreditch,
February 2012.

Introduction
by Adam Cadwell

When I drew my first autobiographical comic strip in late August 2006 it was an experiment. I was trying to recreate the day to day observations of Harvey Pekar's American Splendor stories in the 3 or 4 panel format of James Kochalka's diary comic American Elf. I thought I would make 7, one for each day of the week, and print them in a mini-comic using my desktop printer and a long arm stapler. I called it The Everyday, not because I drew a comic every day but because that's what I wanted the comic to be about. I had no idea I would be drawing this comic for 4 years.

Over that time I learnt a lot about writing and drawing comics. After the first 7 I made another 7 and printed another mini-comic. And then another one. And another. These early strips are all over the place in terms of what moments I picked from my daily life but also in terms of my artistic style. I cannot look at them without wincing. Not just because I can draw much better now, but because thinking back I didn't realise how much I had to learn. Please read them swiftly.

It wasn't until I put my strips online as a web-comic did I really start to improve. I gave myself a weekly deadline and this short timescale was crucial. It caused me to keep an eye out for those day to day moments that we easily forget or pass by. I started and finished something every week and put it online for anyone to see. The instant feedback and support from not only friends but complete strangers gave me a boost to make more. I learnt that the strips I thought were just okay often got the most comments and the ones I thought everyone could relate to were often met with internet silence.

After the 50 comics mark, I felt my style started to find its feet. The art was more consistent and I was starting get a feel for what to write about. I left out the more personal, emotional, relationship content. Plenty of other diary comics made that the focus. I started to use Little Adam, the cute, floating, cartoon version of myself, more sparingly too. When I did use either it was important that the joke or observation didn't rely on them and that they helped the reader relate. I was starting to get comfortable with silent storytelling too. I've always felt the strongest comics have no words in them at all. I was particularly proud of my hundredth strip 'The Wait'.

Despite pushing the focus away from myself and onto the little moments in life, looking back, these 200 comics tell a lot about my life over those 4 years. By drawing comics and putting them out into the world I have met some of my best friends and visited places I would never have gone.

I met Marc Ellerby at a comic show in Birmingham in 2007, recorded in strip #59 in which I am drunkenly chatting up his friend Jessica. In spite of this a bromance developed and we have been the best of friends ever since. Marc drew a journal comic too and we would appear in each other's work frequently, which was always fun. In April 2012 we set up a small publishing imprint called Great Beast which published this very book.

Chris Madden deserves a special mention for being my "long suffering housemate" as one reviewer put it. I lived with Chris for 2 years and this introduced a sweet, domestic basis for many of the strips and many of my favourites. I thank him for letting me draw him so often and for putting up with me for 2 years.

Chris Dillon, Anna McGrath, Gary Lawson and Kayla Hillier appear many times too and they all have my love and gratitude. I thank everyone who let me draw them in my work.

These strips took me all over the world, selling my comics in places far away from my home city of Manchester where the bulk of The Everyday takes place. Through these strips I can recall the colours and the heat of New York in June, the evening light on the water in Stockholm and the sounds and the energy of the Glastonbury Festival. And then there's Toronto. The home of the girl I fell in love with.

I'll say no more. It's all here for you to read. I sincerely hope you enjoy them. I enjoyed making them. I hope that you see a part of your life in The Everyday and see more of the everyday in your life.

Adam Cadwell

September 2012.

by Adam Cadwell

1

31st August 2006

2

3

1st September 2006

'Punk?'

10th September 2006

'Snikt'

16th September 2006

FOR MY FRIEND **DAN**'S BIRTHDAY WE WENT TO WATCH 'CLERKS 2'

MIKE
in a bad mood

DAN
31 today

MAIA
Mrs. Dan

ME

DAN IS A BIG FAN OF THE ORIGINAL SO IF THE SEQUEL SUCKED IT WOULD HAVE PUT A DOWNER ON THE NIGHT

KEVIN SMITH DID NOT DISAPPOINT US. AFTERWARDS WE DRANK IN THE MILD EVENING AIR AND TALKED ABOUT THE FILM

Its odd how a film with so many gross moments can make you feel so warm inside

WE MOVED ON TO TIGER LOUNGE WHERE DAN DRANK DANILLAS* UNTILL HE WAS DRUNK.
THE NEXT MORNING I AWOKE TO A STORM. I SLEPT A FEW HOURS MORE AND WOKE UP TO A SUNNY DAY. I LISTENED TO 'ABC' ON REPEAT (IT WAS IN THE FILM) AND REMEMBERED WHAT A GOOD NIGHT IT HAD BEEN.

* DOUBLE GALLIANO VANILLA LIQUOR, ½ SHOT TIA MARIA, MILK & CREAM

23rd September 2006

7

Incomplete Mouse

THE CREATIVE PROCESS CAN GET VERY FRUSTRATING WHEN I OVER-THINK THINGS

WHEN I WAS A KID DRAWING WAS ALWAYS FUN AND CAME NATURALLY

ON MY FIRST DAY OF PRE-SCHOOL WE HAD TO MAKE A MOUSE OUT OF A TOILET ROLL TUBE...

...BUT I HADN'T FINISHED MINE BY THE TIME WE HAD TO GO LISTEN TO A STORY.

my mum

I CRIED ALL THE WAY THROUGH 'AN OWL AND A PUSSYCAT' THINKING OF MY INCOMPLETE MOUSE ALL ALONE IN THE HALL

SO I GUESS IT'S ALWAYS BEEN DIFFICULT BUT ITS THE STRUGGLE THAT MAKES IT WORTHWHILE.

September 2006

29th September 2006

"Beetle Hair"

SO I GO TO THE SOUP KITCHEN FOR LUNCH. ITS NEARLY 3 SO ITS QUIET.

AS I'M DECIDING WHAT I WANT I PICK SOMETHING OUT OF MY HAIR AND DROP IT WITHOUT REALISING WHAT I'M DOING

I LOOK DOWN AND THERE'S A FRIKKIN' BEETLE

23rd October 2006

11

Halloween "Special"

31st October 2006

CHRIS DOHERTY AND I HAD JUST SEEN SIMON PEGG AND NICK FROST TALK ABOUT THEIR NEW FILM 'HOT FUZZ'

AT THE END THEY WERE THROWING HOT FUZZ T-SHIRTS INTO THE CROWD

Why was she crying? That was ace

Maybe she's upset because she didn't get a t-shirt

I know how she feels

8th November 2006

☆Gary☆ in "THE LEAP"

TOLD TO ME November 2006

Sam's grapes

22nd November 2006

ALL TOMORROW'S PARTIES: NIGHTMARE BEFORE CHRISTMAS, BUTLINS HOLIDAY CAMP, MINEHEAD

IN A FUNCTION ROOM NORMALLY USED FOR HUGE GAMES OF BINGO AND WOEFUL VARIETY PERFORMANCE, I WATCH A 60 YEAR OLD MAN IN THE TIGHTEST JEANS I'VE EVER SEEN TAKE TO THE STAGE, THE GUITARS HOWL THROUGH STATIC AND THE CROWD ERUPTS

STOOD ON THE RAILINGS IN FRONT OF THE SPEAKERS I CATCH HIS EYE. AS HE GROWLS AND SCREAMS HE STARES RIGHT AT ME FOR LONG MOMENTS. IT WAS THRILLING.

LATER, HE INCITES A STAGE INVASION, WE ALL SEE HIS ASS AND MY EARS HUM FOR THE REST OF THE WEEKEND

8th December 2006

16

" the dilemma "

I HAD FOUR HOURS TO KILL BEFORE MY TRAIN HOME ON A CHILLY MONDAY MORNING IN TAUNTON. I WAS TIRED, HUNGOVER AND EXTREMELY HUNGRY. I WAS ALSO BROKE.

I CONTEMPLATED KILLING A DUCK

INSTEAD, I TOOK MY 28 PENCE TO THE CHEAPEST SUPERMARKET I COULD FIND. IT WAS A STARK CONTRAST TO THE EXCESS OF THE WEEKEND.

Baked Beans 29p | Beans and Sausage 58p | Butter Beans 25p | Chopped Tomatoes 33p | Diet Lemonade 30p | Jui Car 49

Nope Nope Urgh Nope

MY ONLY OPTIONS, OTHER THAN A CABBAGE, WERE A LOAF OF BREAD OR A PACKET OF GINGER NUTS.

20p

GINGER NUTS

I can't choose!

BREAD

BREAD

20 MINUTES LATER...

God bless cheap supermarkets

POOR QUALITY BISCUITS NEVER TASTED SO GOOD.

11th December 2006

17

24th December 2006

19

MY WINDOW BLEW IN ON 12th January 2007

20

8th March 2007

14th April 2007

21

'God bin'

18th April 2007

22

"Fond Farewell"

DAMN THE iPOD SHUFFLE! ONE MOMENT I'M SLOWLY WAKING UP ON THE BUS TO WORK...

...THE NEXT I'M LYING NEXT TO HER IN MY BED WHILE SHE SOFTLY SINGS ALONG, HER VOICE FULL OF SORROW

AND I'M DIPPED IN MELANCHOLY FOR THE REST OF THE DAY. I COULD SKIP THE SONG, BUT I NEVER DO.

24th April 2007

Comics in the Bar

GARY DISCOVERS THE STRIP I DREW ABOUT HIM

Ahh! What's happening?

KEV SHOWS ME A NEW FLYER FOR HIS NIGHT

Look at the little boy drawing!

DOT DASH

Scubar

That's Jeffrey Brown, he's our age

GARY AND I PONDER A NEW COMIC IDEA

ELEPHANT BOY

"Secrets Revealed!"

HELLO THERE... JOHNNY MERRICK!

10ᵗʰ May 2007

11th May 2007

11th May 2007

BRISTOL

13th May 2007

14th May 2007

28

22nd May 2007

'Hangover #411'

3rd June 2007

30

23rd June 2007

26th June 2007

'WITHOUT A TRACE'

29th June 2007





3rd July 2007

34

Six Summer days of rain

6th July 2007

Museum

11th July 2007

36

DON'T PANIC. DEPRECATE.

THERE HAS BEEN SOME REDUNDANCIES AT ONE OF THE AGENCIES I WORK FOR. I WATCHED SIMON PUTTING HIS THINGS INTO A CARDBOARD BOX LIKE IN AN AMERICAN FILM.

THE CLICHÉ AMUSED ME BUT I ALSO FELT SAD FOR HIM. IT WAS A STRANGE FEELING AND I DIDN'T KNOW WHAT TO SAY OR HOW TO ACT SO I JUST TURNED BACK TO MY DRAWING.

16th July 2007

FREAK!

A STRANGE MAN CAME TO COMICS NIGHT AND SAW THE 'WITHOUT A TRACE' STRIP IN MY LATEST EVERYDAY COMIC. HE CLEARLY MIS-READ IT AND ASKED ME IF I KNEW A "FRIEND" OF HIS WHO DREW TRANSFORMER PORN COMICS AND WAS MADE HOMELESS BY HIS NEIGHBOURS WHO CALLED HIM A PAEDO.

Nooo...this was on TV

I'll bring some to show you

Look, I really don't want to see it if its got kids in it

Danger, Will Robinson!

Oh

So what do you want to do with your comics?

I'd like to make a living from it one day

No, that'll never happen. You'll never do it.

Well, it is possible

No, you'll never do it, not you. You know Johnny Ryan? Even he doesn't make a living from it!

Riiight. There's a lot of others that do.

No, you'll never make a living from it. Nope.

So is anyone going for a drink after this?

19th July 2007

39

40

26th July 2007

☆ Ben ☆

42

30th July 2007

2nd August 2007

44

11th August 2007

19th August 2007

46

AFTER THREE DAYS OF RAIN ON OUR HOLIDAY, CHRIS AND I TOOK A DIP IN THE MINI-POOL

47

22nd August 2007

VVUUUUUUUUUUUUmm

Have you set your watch back yet?

vvvvuuuuuu...uumm

No, not yet. Guess I can do it now.

I FELT A LITTLE SAD AS I CHANGED THE TIME, AS IF THIS SMALL ACT MARKED THE EXACT MOMENT MY HOLIDAY WAS OVER.

(I'M SO EMO)

26th August 2007

48

 the *Everyday* #50
SUPPORTING CAST
(in order of appearance)

 ROSS

 SARAH

 DAN

 MAIA

 BACK OF MIKE'S HEAD

 ANNA

CHRIS

mum, 1985

 DOM

 MARIE

 NIKI

 A BEETLE

 Do I count?
LITTLE ADAM

 GARY

 CHRIS

 SAM

 IGGY POP

 A PACK OF GINGERNUTS

 KORENA

 PAUL

 HAROON

 THE TOM

 JAIME

 ABBY

 ANDY

 A BEE

 PAUL

 JO

 LEE

 SIMON

 A FREAK

 JIM

 BEN

 A TRAMP

 TINY DOG IN A DRESS

 CHRIS

"THANKS GUYS!"
Cadwell
September 2007

50

the "MAGIC" bus

12th September 2007

I WAS OUT CLOTHES SHOPPING AND I SAW A PAIR OF THIN BLACK JEANS I THOUGHT I'D TRY ON. THEY WERE A LITTLE TOO TIGHT.

"UH OH" I THOUGHT, "I'M WEARING HIPSTER JEANS" IF YOU'RE OLDER THAN 21 AND YOUR LAST NAME ISN'T RAMONE YOU SHOULD NOT BE WEARING THESE.

EVEN THOUGH NO-ONE SAW ME I FELT EMBARRASSED AND A LITTLE OLD. I WENT TO ANOTHER SHOP AND FOUND SOME DARK BLUE BOOT CUT JEANS. THEY'RE NOT HIP. THEY SUIT ME.

15th September 2007

`Dragon Breath`

Like the first fat bumblebee of Spring, the first day I can see my breath tells me Autumn has arrived.

When I was a kid, this meant I could run around the play-ground pretending to be a Dragon.

Now it means it's time to don my Winter coat but who's to say I can't still feel a little like a Dragon?

18th September 2007

19th September 2007

54

20th September 2007

25th September 2007

29th September 2007

30th September 2007

58

ON THE STREETS OF BIRMINGHAM

13th October 2007

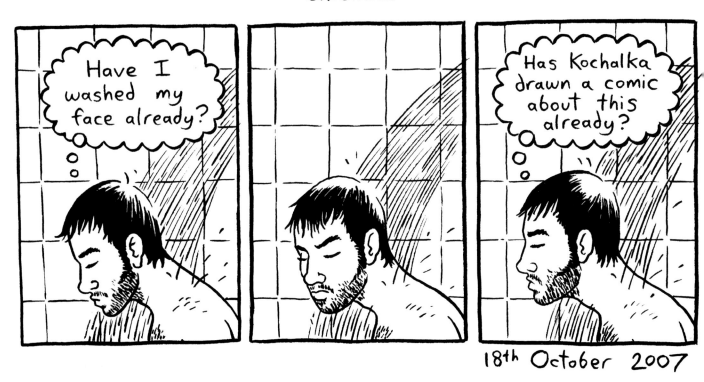

18th October 2007

JAFFA CAKE BLIND

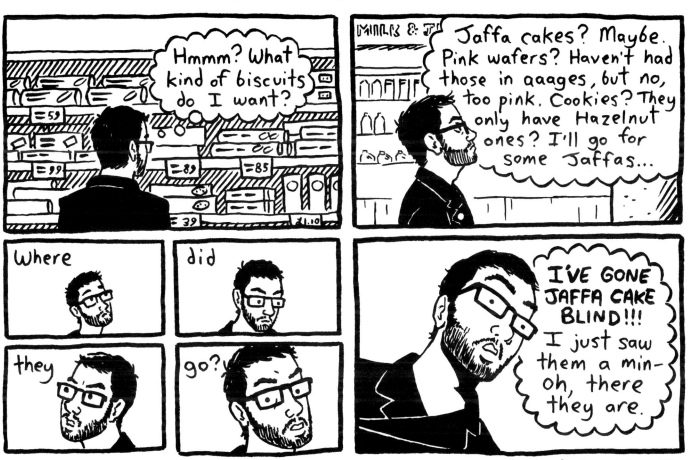

24th October 2007

61

Goooooodge?

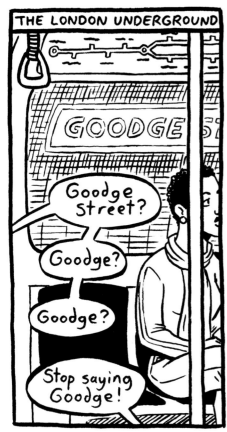

THE LONDON UNDERGROUND

GOODGE

Goodge Street?

Goodge?

Goodge?

Stop saying Goodge!

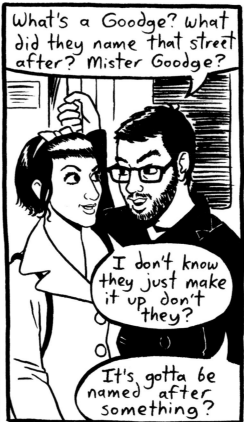

What's a Goodge? What did they name that street after? Mister Goodge?

I don't know they just make it up, don't they?

It's gotta be named after something?

We were just asking ourselves the same question earlier

See? Even he's like "What the hell?"

GOODGE

28th October 2007

HALLOWEEN "SPECIAL"?

31st October 2007

16th November 2007

22nd November 2007

ALEXIA, A CANADIAN, WAS HELPING ME PACK AND TALKING OF GOING HOME FOR CHRISTMAS

I can't wait to eat at Wendy's

What's the difference between Wendy's and Denny's?

There's a BIG difference!

Well, what is it?

I don't know, I've never eaten at Denny's

You're funny!

24th November 2007

Moving Day

Fun with Beards

THE FULL BEARD

THE LEMMY

THE HANDLEBAR

THE CHAPLIN

CLEAN SHAVEN

THIS IS HOW I SPENT MY FRIDAY AFTERNOON

7th December 2007

14th December 2007

23

CHRIS D AND I WATCHED 'THE NUMBER 23' ON HIS XBOX MEDIA CENTRE

IMMEDIATELY AFTER...

The time on my Xbox is all wrong. Let me guess...

It's the 23rd! I hadn't realised.

I didn't notice that!

And what time is it?

23rd December 2007

27th December 2007

1st January 2008

9th January 2008

73

74

14th January 2008

button

14th January 2008

"4-6 weeks"

15th January 2008

19th January 2008

2nd February 2008

PUB OF THE APES

GARY WAS TELLING ME ABOUT AN OLD GORILLA WHO COULD SPEAK IN SIGN LANGUAGE

AND WHEN ASKED WHAT SHE WAS THINKING REPLIED "JUST FOOD"

WE TALKED ABOUT SELF AWARE THOUGHT AND IF ANIMALS WERE AWARE OF THEIR OWN MORTALITY (GARY SAYS NO). WE DISCUSSED HAVING MONKEYS AS PETS AND 'PLANET OF THE APES' POSSIBILITIES. THEN I ASK...

So when do we get talking monkeys?

We are talking monkeys

10th February 2008

79

Pig Suit Comics

26th February 2008

5th March 2008

"Always Carry Tissues"

7th March 2008

14th March 2008

*a chocolate bar

84

FIRE HAZARD

85

22nd March 2008

inner city pressure

22nd March 2008

AT THE UK WEB & MINI COMIX THING 2008

22nd March 2008

Easter Sunday

Paul

3rd April 2008

89

"Dinner Theatre"

15th April 2008

90

Victory

hhhhrrmmgh

09:58

I win

SHIT! I'M AN HOUR LATE FOR WORK!

Oh wait. It's Saturday

19th April 2008

20th April 2008

22nd April 2008

Etiquette?

2nd May 2008

No-one likes Hawaiian

3rd May 2008

"Vill du följa med upp snygging?"

AT THE BRISTOL INTERNATIONAL COMIC EXPO
* MUSEUM OF COMIC AND CARTOON ART FESTIVAL

11th May 2008

96

15th May 2008

EDGE STREET

Liz

Cadwell
Liz G.

24th May 2008

The WAIT

WHHRRZZZZZZZZZWHHRR
clack clack

end.

NY ♡ ME

2nd June 2008

A LESSON LEARNED

8th June 2008

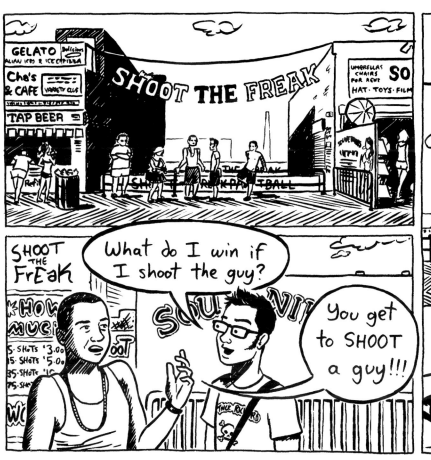

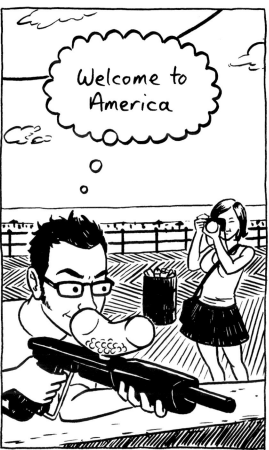

9th June 2008

103

11th June 2008

'Home Sweet Home'

16th June 2008

20th June 2008

Glastonbury

HERE I AM, ALL HAPPY WITH MY-SELF BECAUSE I'VE JUST MADE A NESQUICK CHOCOLATE MILK, SITTING DOWN TO WATCH TV...

... FORGETTING IT WAS GLASTONBURY. THE SUN WAS SHINING AND I WANTED TO BE THERE. MY MILK WAS A SMALL CONSOLATION.

28th June 2008

12th July 2008

14th July 2008

109

Smoooooooth!

23rd July 2008

MANCUNIAN SUMMER

29th July 2008

Chris is funny

CHRIS WAS TELLING ME ALL ABOUT HIS DAY

So they gave me like 70 forms to do yesterday and I had about 37 left over this morning plus today's work and they were all like "Why haven't you done these forms?" and I was like "Because they're fucking hard!"

ILLEGALLY DOWNLOADING TELEVISION SHOWS

But these new forms we've got are really simple. I kept saying "But they haven't filled..

YAWN

..out this bit" "Don't have to" "or this bit" "Don't have to" "or—

That was a genuine yawn by the way

It's not the yawning I mind...

...it's the interrupting

5th August 2008

112

Manchester, City of Contrasts

14th August 2008

* OUR REMOTE DOESN'T CLICK

16th August 2008

115

29th August 2008

HUNGOVER SLAPSTICK

30th August 2008

"Neopolitan: So there's no arguing"

13th September 2008

18th September 2008

19th September 2008

I'm a student; music production. I don't do anythin' really. I had this **mental** night last night. I was at this party and drank **4 litres** of cider! Man! Then I ended up at my mate's and we did some **ket**. I was trippin' in a **crazy** K-hole! Then my mate found a bottle of **Rum**! Whoa! And I slept on his sofa, **proper** uncomfy! I got a well sore neck, I'm knackered!

26th September 2008
(Fresher's Weekend)

BIRMINGHAM

04 OCT 2008

DEFLUFFINATOR

5th October 2008

10th October 2008

124

125

16th October 2008

126

Cotton Buddy

19th October 2008

SHEMINI ATZERET, APPARENTLY

20th October 2008

128

129

31st October 2008

Similar Shirts

23rd November 2008

I WAS MAKING MYSELF A PACKED LUNCH BEFORE SETTING OFF FOR WORK...

WHEN I POPPED A CHERRY TOMATO IN MY MOUTH...

FORGETTING I HAD JUST BRUSHED MY TEETH. I HAD TO GAG OVER THE BIN.

24th November 2008

1st December 2008

19th December 2008

134

A MAN DRESSED AS SANTA CLAUS SHOT AND KILLED NINE PEOPLE AT HIS EX-WIFE'S FAMILY CHRISTMAS EVE PARTY BEFORE SETTING OFF A HOME-MADE INCENDIARY DEVICE AND LATER COMMITTING SUICIDE

COVINA, CALIFORNIA

SONY

THE DOOR WAS ANSWERED BY AN EIGHT-YEAR-OLD GIRL. WHEN SHE APPROACHED THE MAN HE TOOK OUT A HANDGUN AND SHOT HER IN THE FACE

Fuckin' hell!

mum

GEOFF

26th December 2008

135

Fun and Punishment

1st January 2009

137

6th January 2009

Restlessness

9th January 2009

stōo-pĭd'ĭ-tē

15th January 2009

VIRTUA COPS

16th January 2009

141

23rd January 2009

26th January 2009

143

144

...what you wish for

1st February 2009

Shut it, Attenborough!

Panel 1	Panel 2	Panel 3
I WAS WATCHING THE CAVES EPISODE OF BBC NATURE DOCUMENTARY 'PLANET EARTH' ON DVD WHILE EATING LUNCH	... this hundred metre high mound is made entirely of bat droppings. Guano...	...its surface is covered in a thick carpet of cockroaches...
A staggering 3 million wrinkle-lipped bats live here...		Why did I put this on?

...hundreds of thousands of them.

24th February 2009

146

Hope

2nd March 2009

147

148

CRUMBS

JIM MEDWAY HAD KINDLY LET ME ASSIST HIM WITH HIS COMICS WORKSHOP FOR THE DAY AT THE CITY ART GALLERY

What does this picture tell us about this person? Is he kind? Is he angry? What **job** might he have?

I think he looks kind!

He looks poor

He looks... looks like he was a soldier

He looks lonely...

LATER, AFTER JIM TOLD THE KIDS WHO THE MAN WAS

He looks like R...Robert Crumbs doesn't he?

Haha, yes! Yes he does

4th March 2009

Crusts

(CHRIS IS PLAYING RESIDENT EVIL 5)

18th March 2009

150

Bowling with Beth!

26th March 2009

1st April 2009

152

GETTING TICKETS

153

5th April 2009

85 DAF

154

22nd April 2009

LURCH

155

22nd April 2009

STOCKHOLM PART 3

AT THE SWEDISH SMALL PRESS EXPO

25th April 2009

14th May 2009

Lost Girl

160

26th May 2009

162

GLASTONBURY PART 1

EXCITED, I ARRIVE AT THE DROP OFF FIELD, DRIVEN THERE BY MY LITTLE SISTER JOLENE...

...WHERE I HAVE TO QUEUE FOR A COACH TO TAKE ME TO THE FESTIVAL SITE WE'D JUST PASSED IN THE CAR

Great

I CHAT WITH ADAM AND FREYA, A COOL COUPLE IN THE QUEUE AHEAD OF ME

There's been a 'fatality' in Pilton so they've closed the roads. The coaches are going the long way 'round which is takin' 2 hours!

5 (FIVE!) HOURS LATER WE GET ON A COACH. ON THE WAY IT STOPS TO LET ANOTHER COACH PASS BY. SOMEONE CRIES OUT MOCKINGLY

We're here!

I LOOK OUT OF THE WINDOW

Whitsend

Wednesday 24th June 2009

163

Thursday 25th June 2009

Friday 26th June 2009

Friday 26th June 2009

166

Friday 26th June 2009

AFTER BEING AT THE FRONT FOR NICK CAVE I HEAD TO THE BACK OF THE MAIN FIELD TO WATCH BLUR WITH MY FRIENDS.

BLUR WERE ON TOP FORM AS IMPRESSIVE AND FUN AS THEY'VE EVER BEEN. DAMON BROKE DOWN IN TEARS DURING 'TO THE END'. HE WOULD LATER CLAIM THIS PERFORMANCE ONE OF THE HIGHLIGHTS OF HIS MUSICAL CAREER.

THE ENTIRE CROWD ALL THE WAY TO THE BACK OF THE FIELD SING ALONG LIKE WE'RE KIDS IN OUR BEDROOMS AGAIN.

IT HAD BEEN MY FAVOURITE GLASTONBURY YET AND THIS WAS A PERFECT WAY TO END IT.

Sunday 28th June 2009

13th July 2009

CHRIS' BIG NEWS

29th July 2009

* Sneeze Sparkles! *

25th August 2009

171

Reasons to be Cheerful...

28th August 2009

Building a Desk

18th September 2009

173

24th September 2009

THE RIDDLE OF SUPERMAN'S CAPE: A JOE LIST MYSTERY

4th October 2009

FAMILY DINNER

10th October 2009

HALLOWEEN "SPECIAL" 4

GETTING READY

I just found forty quid!

You should **Tweet** about it!

31st October 2009

1st November 2009

179

4th November 2009

23rd November 2009

180

Do Janeway

1st December 2009

17th December 2009

2nd January 2010

184

23rd January 2009

Déjà Goodge

29th January 2009

3rd February 2010

I'm just gonna get ready to go out

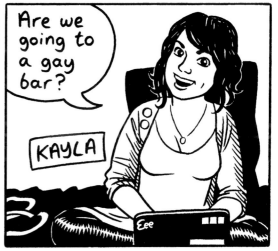

Are we going to a gay bar?

KAYLA

Eee

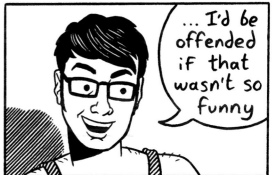

...I'd be offended if that wasn't so funny

6th March 2010

188

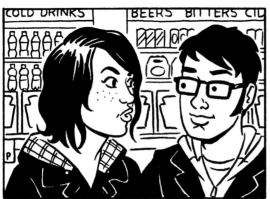

What was that look for?

I thought for a sec I wasn't wearing my glasses but I only wasn't wearing two pairs of glasses

EARLIER THAT EVENING

89p

7th March 2010

189

The Cad-tum

12th March 2010

ROCK, PAPER, KNIFE?

31st March 2010

192

♡ Welcome to Canada! ♡

TORONTO

Get a room

Ha

Ha?

Oh, she's not joking

If you were in Dubai, you'd be in JAIL!

Canadians are nice, I promise

26th April 2010

30th April 2010

194

30th April 2010

DINING WITH MARC AND ANNA

3rd and 4th May 2010

GLASTONBURY 2010

Here's the best photo of the festival!

Ha ha!

Oh, it's gone away

prod

Did you touch the screen to get it working?

Maybe

KRISTIAN

What is technology doing to us, eh?

27th June 2010

197

2nd July 2010

6th July 2010

#200!

12th July 2010

About the Author

By now you probably know far too much about Adam Cadwell and have seen one too many drawings of him topless.

Since the conclusion of The Everyday, Cadwell has continued to work as a cartoonist and freelance illustrator in Manchester, England.

After 4 years of drawing his own face he now creates fictional comics such as Blood Blokes and The King of Things as well as contributing to Nelson from Blank Slate Books (2011).

In 2012, Cadwell launched Great Beast Comics with Marc Ellerby and founded the British Comic Awards.

www.adamcadwell.com